SEPTEMBER COMMANDO

GESTURES OF FUTILITY AND FRUSTRATION

SEPTEMBER COMMANDO

GESTURES OF FUTILITY AND FRUSTRATION

JOHN YATES

AK PRESS
EDINBURGH · LONDON · SAN FRANCISCO
in association with
ACTIVE DISTRIBUTION
LONDON

SAM SAYS

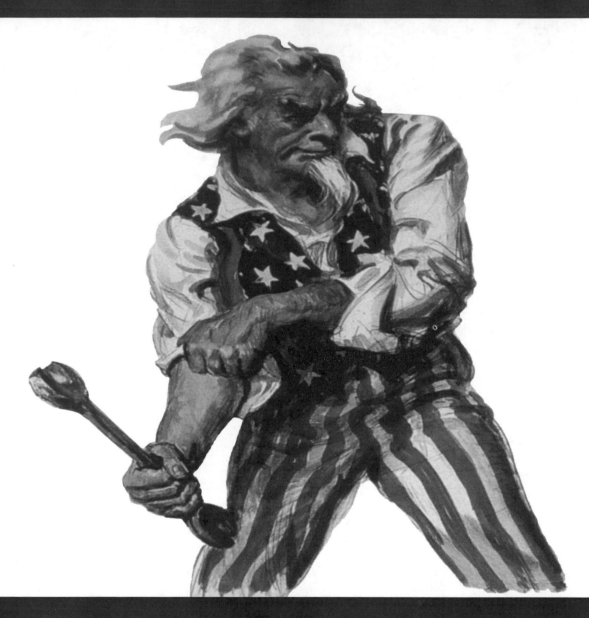

SAY UNCLE

SAM SAYS

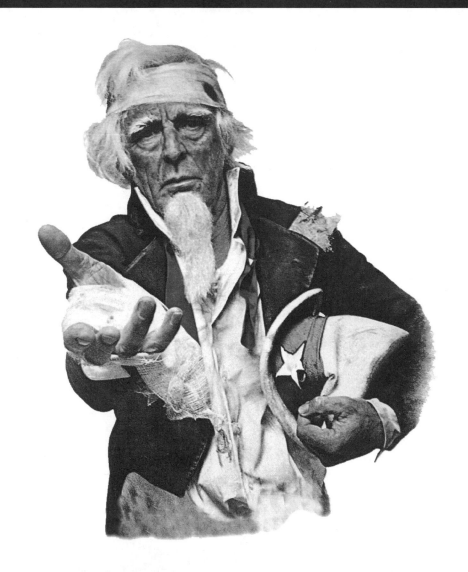

OK, UNCLE

This one's for the little fella, Max; the biggest thing that ever happened to me. Jennifer, for understanding above and beyond the call. Mom, just for being Mom. And my brother, Paul; here's to Del Griffith, kiddo.

Printed in the United States of America.

ISBN 1-873176-52-X

 Library of Congress Cataloging-in-Publication Data
 A catalog record for this title is available from the Library of Congress.

 British Library Cataloguing-in-Publication Data
 A catalogue record for this title is available from the British Library.

First published in 1996 by:
AK Press, PO Box 40682, San Francisco, CA 94140-0682, USA.
AK Press, PO Box 12766, Edinburgh, EH8 9YE, Scotland.
in association with
Active Distribution, BM Active, London, WC1N 3XX, England.

Contact John Yates/Stealworks directly at
PO Box 460683, San Francisco, CA 94146-0683, USA.

Design & Construction: JOHN YATES/STEALWORKS
Copy Editing: RAMSEY KANAAN
Cover Film Separations: H & H PLATEMAKERS
Mechanical Preparation, Printing, & Binding: BOOKCRAFTERS

Production specifications:
The contents of this book were produced on a Power Macintosh 7500/100 with 48MB RAM, a 500MB internal drive, an external 270MB drive, and a Sony Multiscan 17sf color monitor. All images were scanned on a Hewlett Packard ScanJet IIcx at 300 dpi. All images were manipulated in Photoshop 3.0 using various standard filters. Page layouts were created in PageMaker 6.0. All data files were backed up on an Iomega Zip 100 drive. I was wearing clean underwear and drank several cases of Coca-Cola, 12 fl oz cans.

Page iv: UNTITLED (SAY UNCLE). 1995.
Page v: UNTITLED (UNCLE SAID). 1995.
Page vii: UNTITLED (DAMNED NAZIS). 1995.

"If you assume that there is no hope, you guarantee that there will be no hope. If you assume that there is an instinct for freedom, there are opportunities to change things, there's a chance you may contribute to making a better world. That's your choice."
 —NOAM CHOMSKY, anarchist and linguist

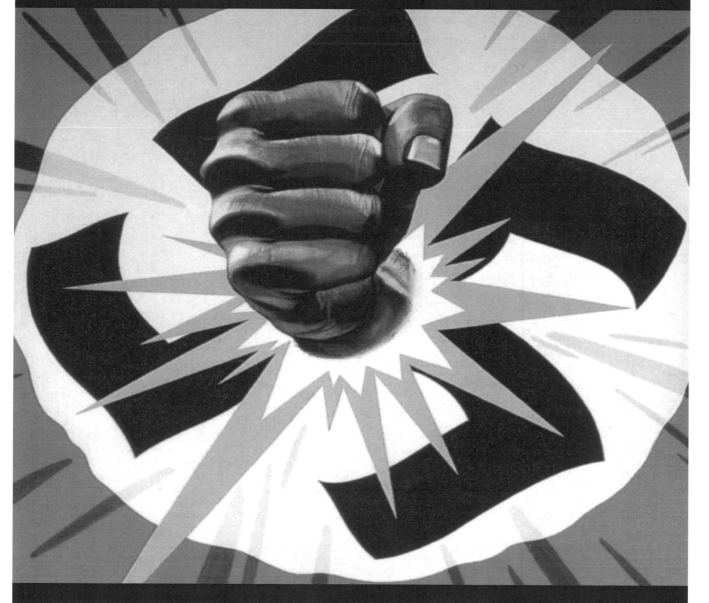

CONTENTS (UNDER PRESSURE)

INTRODUCTION 10

NEWSWEAK 12

 CIVILIAN DEFENSE

 CAMPAIN CONTRIBUTIONS

 HUMAN RACE RELATIONS

 HEALTH (WE DON'T) CARE

 THE RIGHT TO BEAR TEETH

 MILITARY INDUSTRIAL COMPLEXITIES

 ALIVE AND KICKING

 OF COPS AND DOUGHNUTS

 POP CULT(YOUR)

PUNK ROCK VOLUME 80

ACKNOWLEDGEMENTS 95

"There can be revolution only where there is a conscience."
—Graffiti, French student revolt, 1968

SEPTEMBER COMMANDO

We interrupt this program already in progress...

SEPTEMBER COMMANDO: Another rogues' gallery filled with street gallery art and the usual suspects. It's all the conveniently (cold) filtered (tapped at the source) news that's deemed fit to abuse. It's the (limited) power of the (underground) press under press(ure). It's the liberal appropriation of the appropriate to create a (by any) means (necessary) to an end. It's the stealing of an over-the-counter culture made popular by thieves. It's the subtle weaponry of the mass(acre) media acquired and redefined for bluntly defined intervention. It's a Citizen Caine mutiny in which the media supplies the pictures and Stealworks supplies the war. Praise the PowerPC and pass the ammunition.

GESTURES: That's basically all that they are. Token tantrums against the inert status quo. Desparate shots at seemingly bulletproof targets. No magic in this bullet theory, just empty chambers clicking against empty heads. Russian roulette for party members only. These protest images, these choruses of disapproval, are the skinny kid on the beach rubbing the sand out of his eyes. There is no Charles Atlas, just a gymnasium of global apathy exercising their right to maintain ignorance. Another ninety six pages worth of impotent finger pointing. Just so much more paper expended in the recycling war.

FUTILITY: Sometimes you wonder whether it's all worth it. You wonder if anything is ever going to change. You wonder if it does change, then will you be happy. You wonder if others spend as much time entertaining these thoughts. And sometimes you simply don't think about it at all, because the hopes you have are simply turning into hopelessness.

FRUSTRATION: In the end, you just do whatever you can in order to alleviate the impediment. By Any Means Necessary is a slogan one can live by, there really is nothing else to add to that. It is simply the only way to deal with your situation. Frustration with a direction is a world away from frustration with indirection. Knowing your position and its strengths is half the struggle. I happened to be fairly adept artistically. Others have talents I can only envy. You play with the hand you were dealt.

It can be tough to wake up a little, fly right, get it together, to take a good look around, shoot straight, smell the coffee, pay attention, see the big picture, and not just want to climb right back into bed again and pretend it's all a bad dream. Reality can be a painful experience, that's why many choose to live in a state of denial. An homogenized virtual reality, insulated from the world around them by selectively filtered reality bites.

In this once-removed twilight zone, this Realitygate, the plumbers really earn their pay, replacing substance through substantial abuse. Everything gets the Good Housekeeping seal of approval: smart drinks replace smart bombs; laser discs replace laser guided weapons; 'Cops' replaces cops; Clinton replaces Bush; pro-life replaces (pro-choice) life; aliens replace illegal aliens; America On Line replaces an America derailed; Cuba replaces the Soviet Union; Castro replaces Hussein; the Olym-

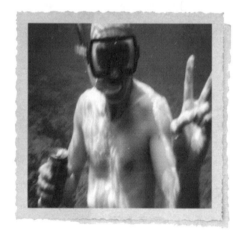

The author in a rare relaxed moment under approximately fifteen feet of Pacific ocean off the shores of Hawaii's Big Island. The trip was part of the pay-off for AK Press securing the rights to his next 13 books, in a contract thought to be worth somewhere in the ballpark of $3.18.

"Immature artists imitate. Mature artists steal."
—LIONEL TRILLING, critic, educator

pics replaces the Reconstruction; the Dream Team replaces the American Dream; 'Days Of Our Lives' replaces the days in our lives; the 'Real World' replaces the real world; "alternative" replaces any real alternative; infotainment replaces information; and television replaces all vision.

As America spirals steadily out of control, so too do her people. They try to address the extremity of the nation's decline through a variety of extreme methods; they experiment with common farm-based chemicals and target symbols of state control. They retreat from society and send mail bombs across the country to get their writings published. They stockpile enough weapons to start World War III, prepare assassination lists, and plan for Armageddon just to exercise their right to bear arms (and grudges). They join hate groups to alleviate their own twisted sense of inequality. They burn mixed-race churches for unknown reasons. They shoot doctors (don't they?) who exercise a woman's right to choice because they've chosen life through death. They squander taxpayer's money on trivial pursuits because they cheat every time they play the game. They allow military personnel to be blown to bits to maintain a national fuel-injected gas consumption addiction. They beat illegal immigrants and legal citizens alike because they wear a uniform, a gun, and a badge. They exploit the nation's heritage and lay waste to our children's future because they see history only in terms of their own lifetime. They could go on for ever...

Then there's the other side of the coin. Those, like myself, who still like to believe in the age of the true believer. Who still want there to be something out there that is better than what we have. Who still think there is hope for a better tomorrow (and not simply one for Chow Yun Fat). Who do whatever they have to do to come to terms with the reality of the world around them. So here I sit, day in and day out, wondering what the hell it is I am trying to do by sitting here day in and day out, never really able to answer that question. And it is because there is no definitive answer that I ask myself, why the hell not? What have I got to lose? In my case, sleep and any form of social life.

And there isn't a whole lot left to be said that isn't simply going to be a repetition of what was said in the 'Stealworks' introduction. I am not a fan of lengthy texts and sincerely detest writing for the most part, perhaps that is why my work is the way it is. I have become just another (willing) victim of the short attention span theater that I find so fascinating, and yet so discomforting. A product of popular culture as much as a product of biology. And it is this product that I am hoping to return to the place of purchase. A cheap shot with an imitation label. Like a twenty dollar fake Rolex bought under the tacit charade of the Free (for a fee) Trade Agreement; it looks like the real thing, just don't expect too much from it.

Which brings us thankfully to the end of that sermon. The pieces featured throughout these pages are essentially unpublished with the odd exception here and there. They are the culmination of ideas developed since I quit publication of 'Punchline' magazine. With no outlet they have sat idle in notepads and data storage devices for too long. The dust has settled and those who know me even partially should know how much I hate dust. Disturbance is good. It signals change. Change is not only inevitable, it is essential.

We now resume our normal broadcast...

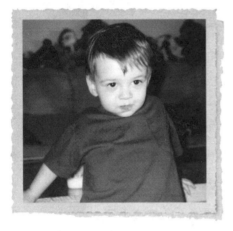

The author's finest creation to date, 24-month old Max, seen here in a moment of casual defiance as 'The Best Of Elmo' is interrupted for yet another confrontation with the intrusive family paparazzi.

"We owe almost all our knowledge not to those who have agreed, but to those who have differed."
—CHARLES CALEB COLTON, writer

11

THEY PERPETUATE

12

OUR INSECURITIES

WE MUST NOT VALIDATE

THEIR ASSUMPTIONS

CAN YOU STAND UP

14

TO THEIR SCRUTINY

PROXIMITY DOES NOT

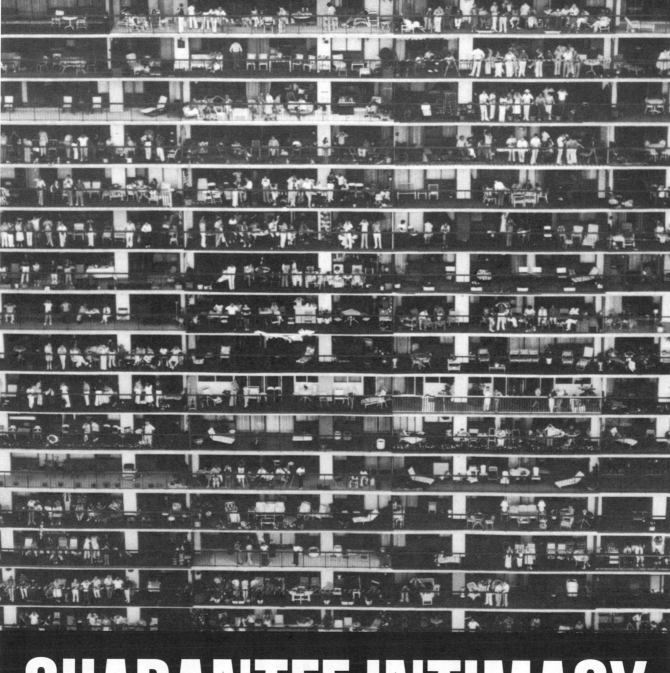

GUARANTEE INTIMACY

THE LIBERATION

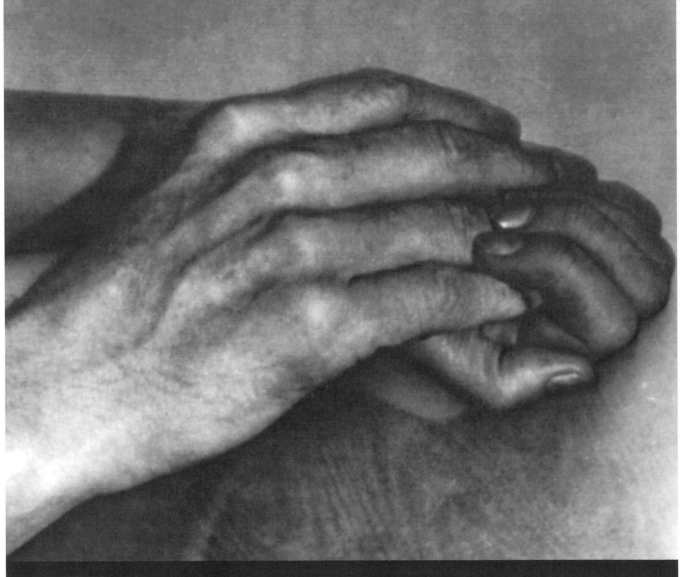

IS IN OUR HANDS

SEPTEMBER COMMANDO

YOUR ATMOSPHERE IS

CHOKING US TO DEATH

TOKEN GESTURES

18

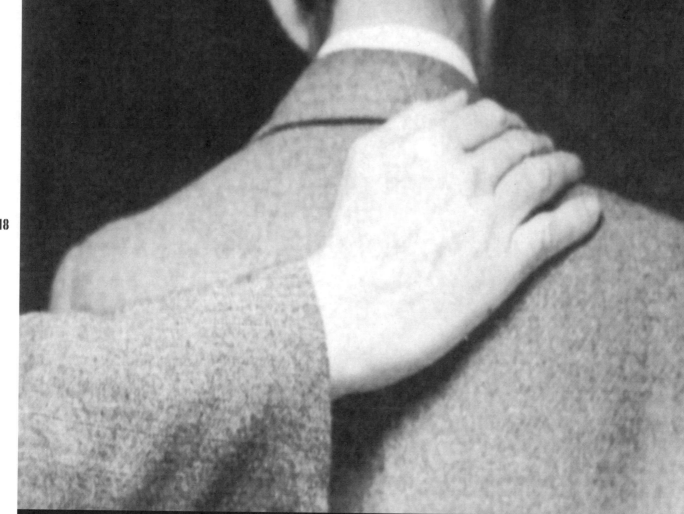

DO NOT MOVE US

WE CANNOT NAVIGATE

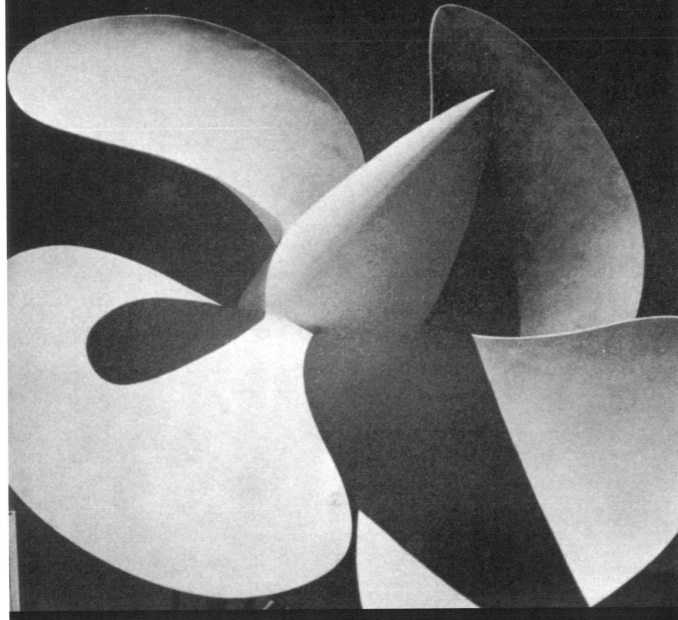

WITHOUT DESTINATION

CAN THEY SECURE

20

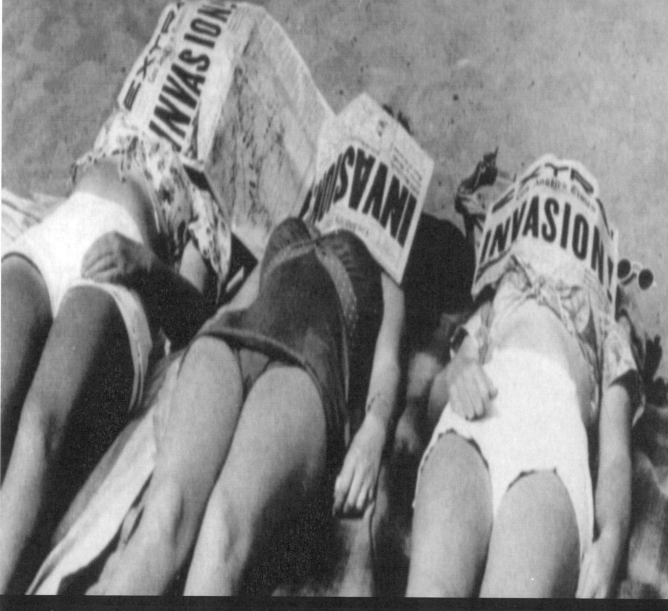

YOUR ATTENTION

OUR OBSERVATION

IS OUR SAFETY NET

WE MUST ASCEND

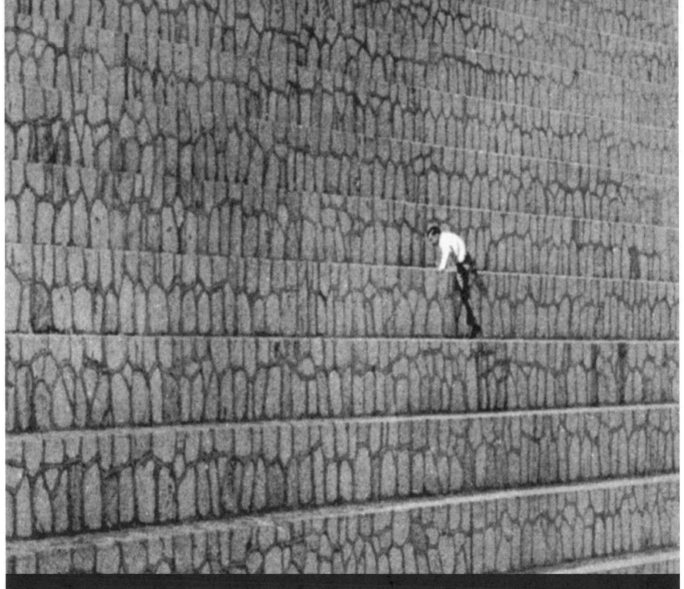

THEIR STONEWALL

THERE IS NO COMFORT

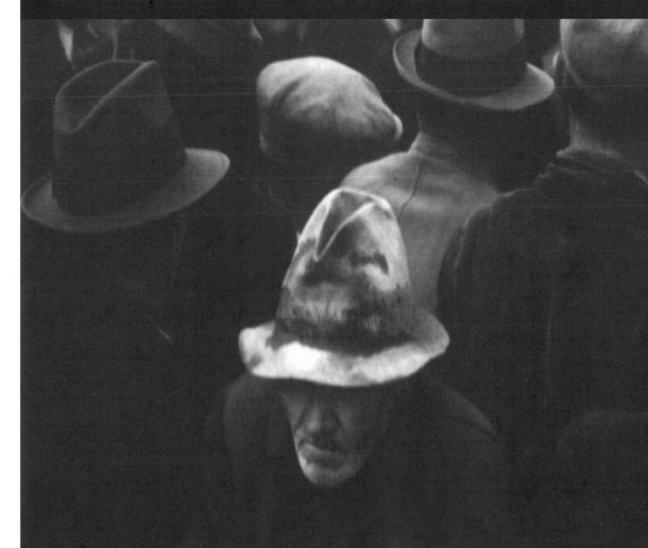

IN YOUR ALIENATION

WE PLACE OUR TRUST

IN GOD WE TRUST

THROUGH FEAR OF SELF

WHILE YOU WATCH THE NEIGHBORHOOD

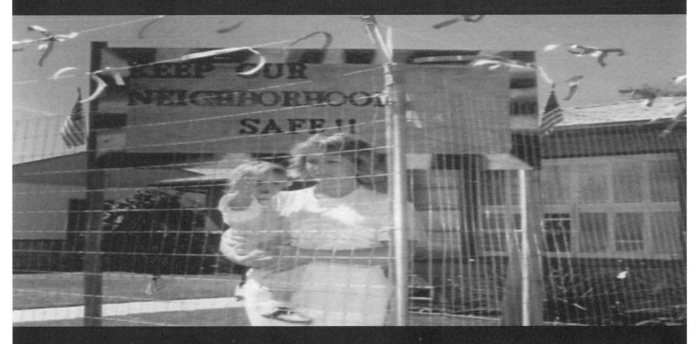

ISOLATION KEEPS THE WORLD AT BAY

THERE IS LITTLE ROOM

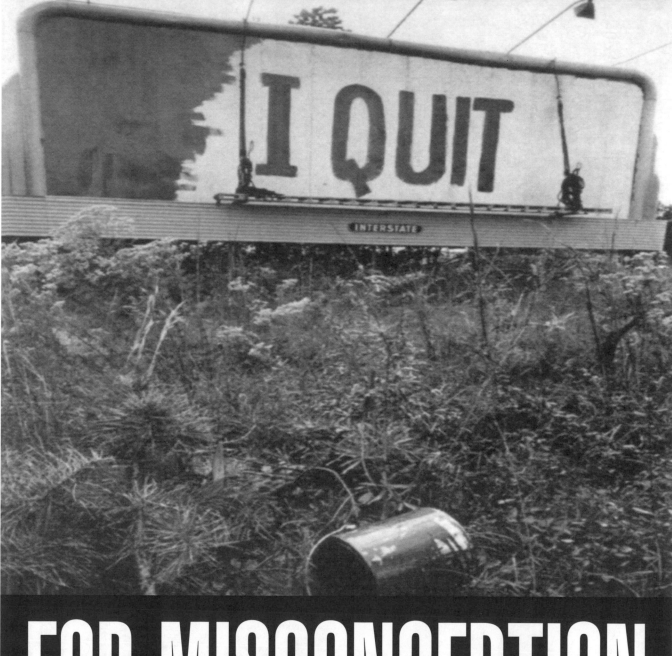

26

FOR MISCONCEPTION

BUILD THEM TARGETS

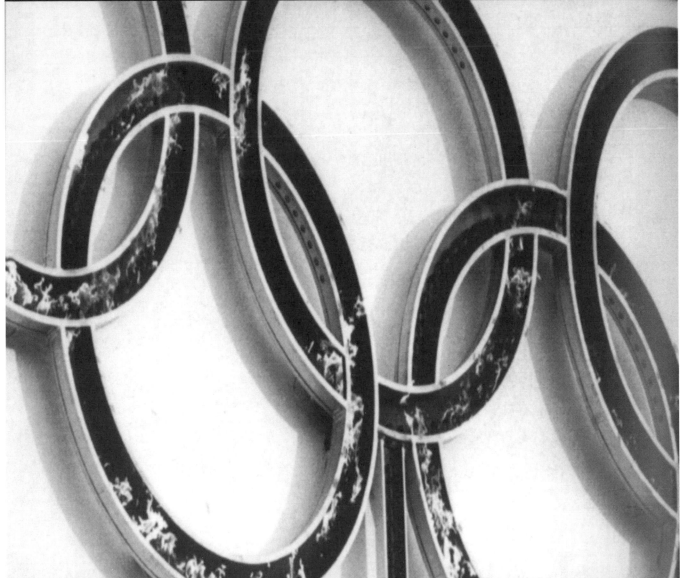

27

AND THEY WILL COME

WE ASSUME OUR GIVEN LIBERTIES

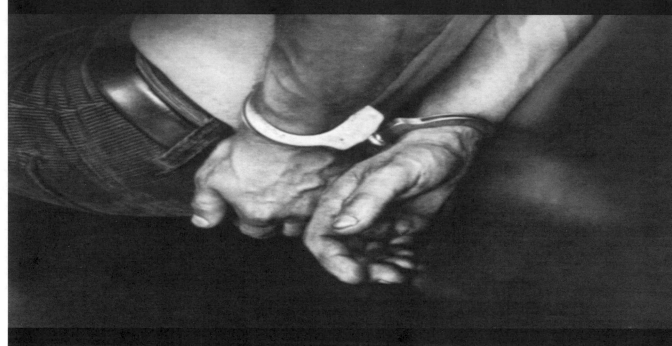

WITH OUR HANDS BEHIND OUR BACK

HEADS THEY WIN TAILS WE LOSE

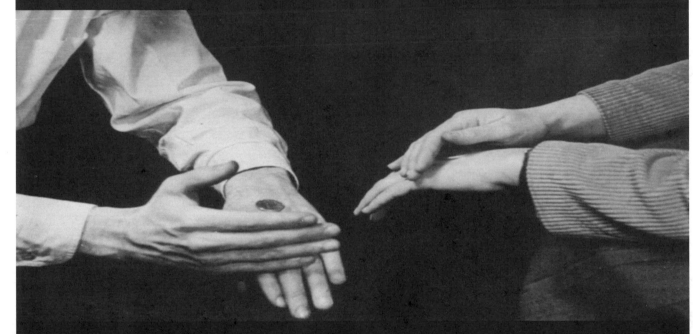

DO NOT GAMBLE YOUR FREEDOM

ARCH (DELUXE) VILLAIN

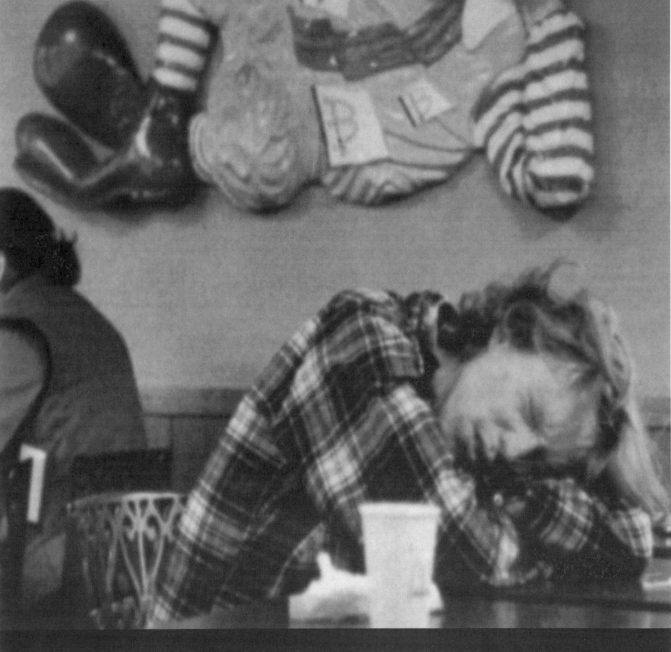

OF THE MINIMUM WAGE

ALL ARE WELCOME

WITH EXCEPTIONS

SEPTEMBER COMMANDO

THROUGH FEAR OF DISENFRANCHISE

WE MANUFACTURE OUR OWN DEMISE

PATRIOTISM WRAPPED SO TIGHT

WE CAN'T SEE PAST OURSELVES

PLEDGE ALLEGIANCE

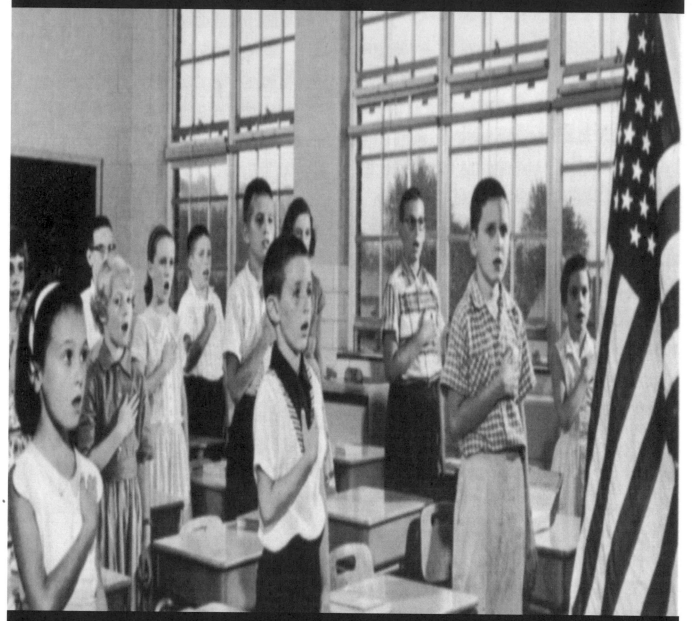

34

TO INDOCTRINATION

TOLERANCE IS

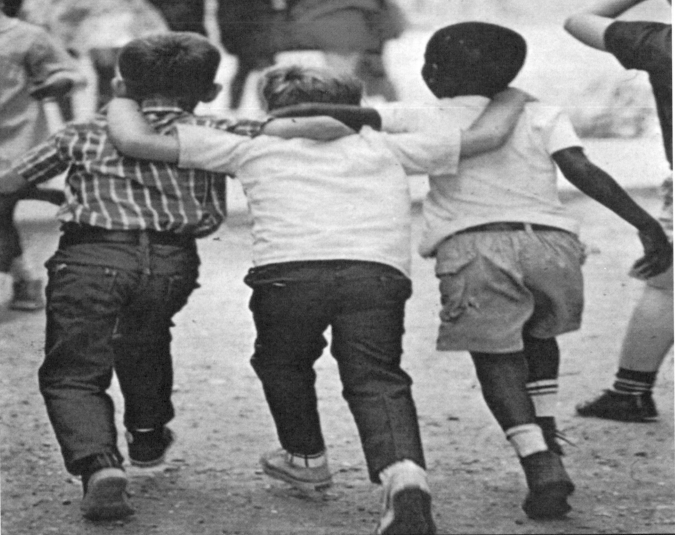

CHILDS' PLAY

FREEDOM OF SPEECH

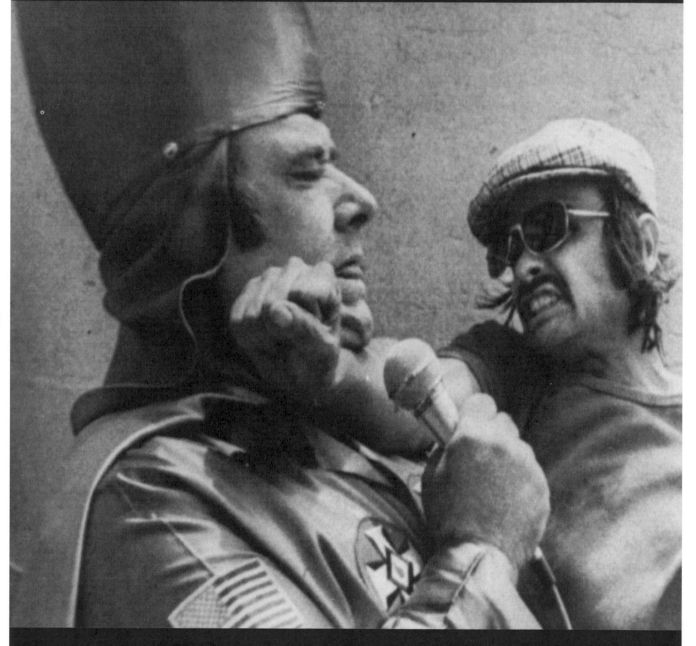

AND JUST TAXATION

IGNORANT PEOPLE

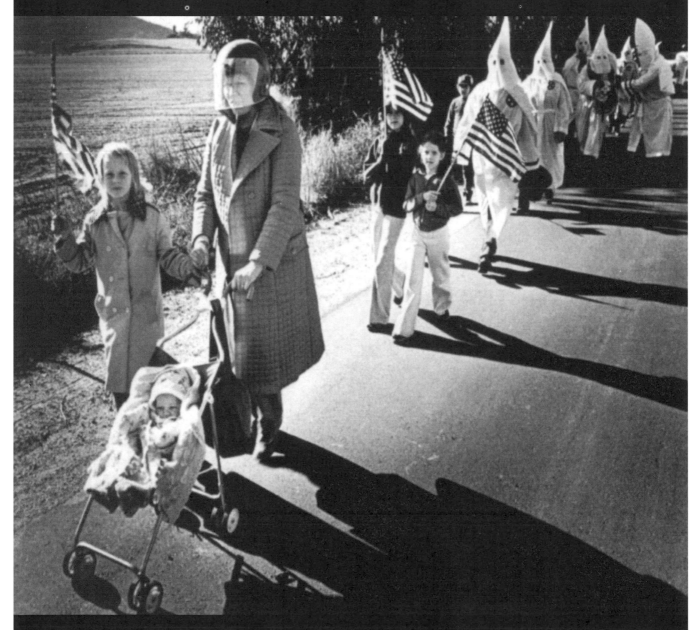

SHOULDN'T BREED

A CONTRADICTION

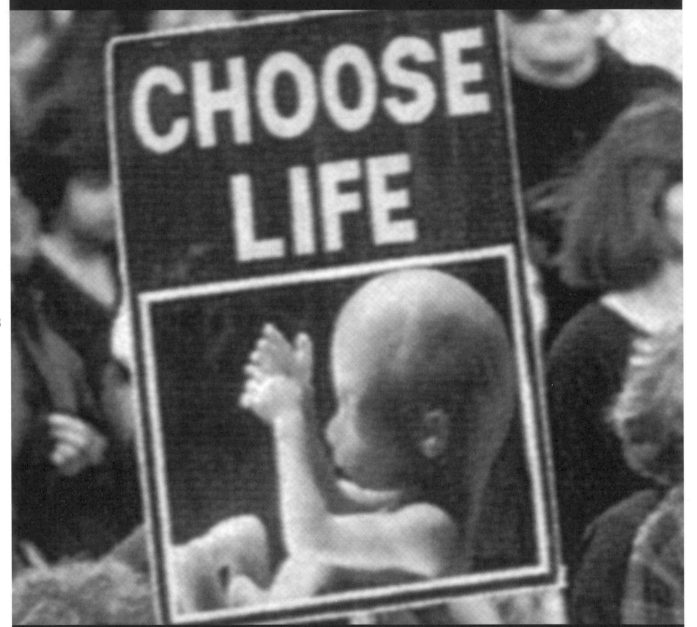

CHOOSE LIFE

IN TERMINOLOGIES

CONTRARY TO POPULAR BELIEF

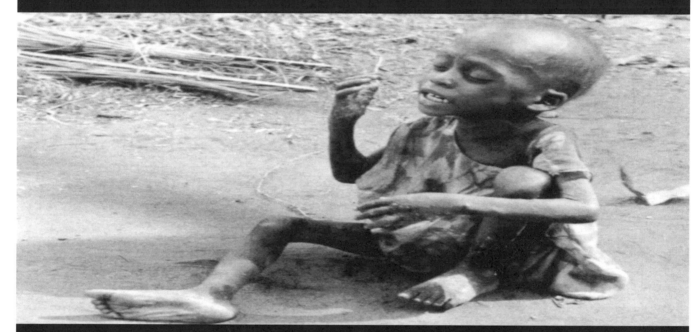

CHILDREN ARE STILL STARVING

AN EYE FOR AN EYE A KILL FOR A KILL

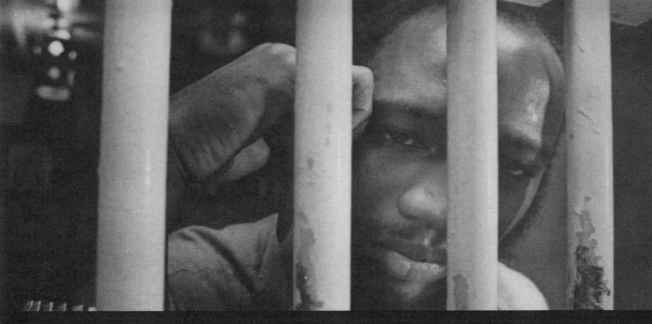

40

SOMEWHERE YOU LOST MY BALANCE

MUST WE ALL STARVE

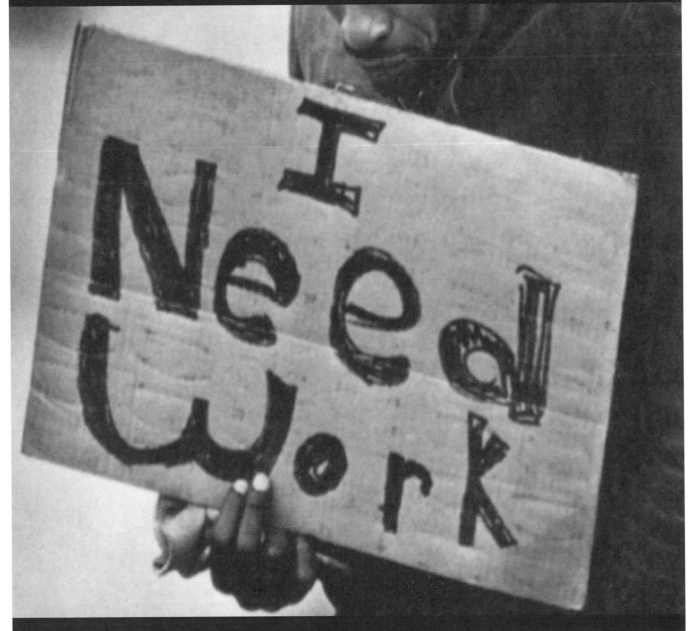

FOR YOUR ATTENTION

THAT'S ONE SMALL STEP FOR A MAN

42

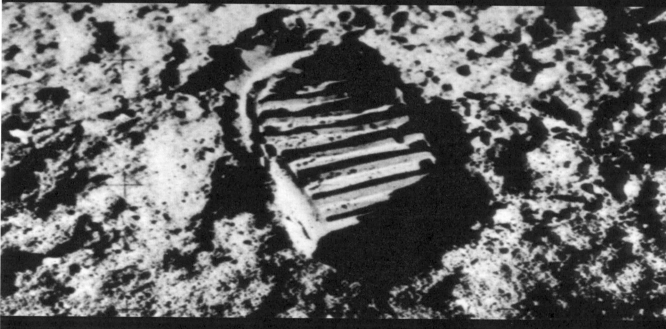

ONE GIANT LEAP FOR WASTED TAXES

MEDIA SEDATION

TRIVIA PURSUIT

YOU ARE THE MACHINERY

44

AND THE MONKEY WRENCH

MAKE EVERY HOUR

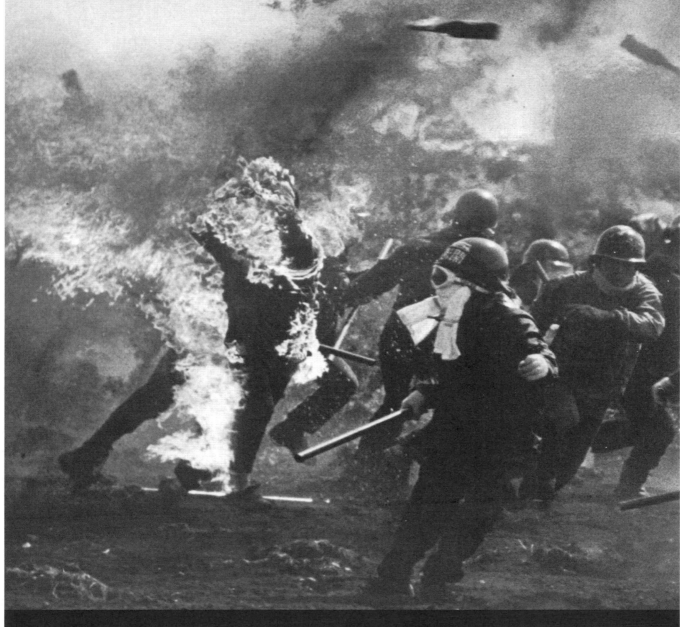

A COCKTAIL HOUR!

45

WOULD YOU RAPE

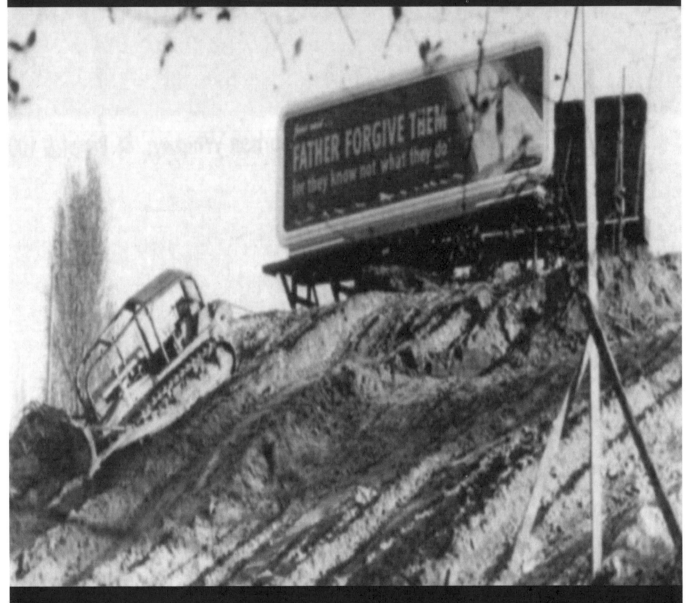

YOUR MOTHER?

WE CAN'T SEE THE WOOD

FOR THE FORMER TREES

WITHOUT A CARE IN THE WORLD

48

WE DO NOT CARE FOR THE WORLD

THEIR HEALTH CARE

OUR BAD MEDICINE

SHOOT US UP WITH HOPE

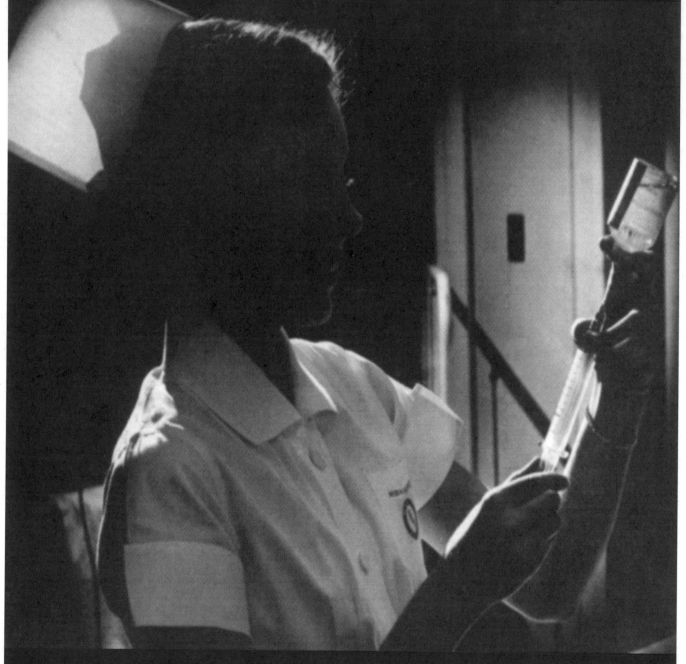

JUST TO PULL THE PLUG

WE TAKE A DEEP BREATH

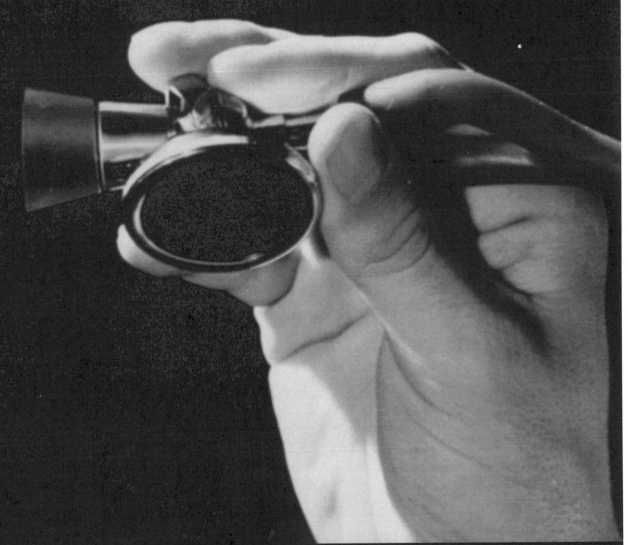

THEY SUCK OUT OUR LIFE

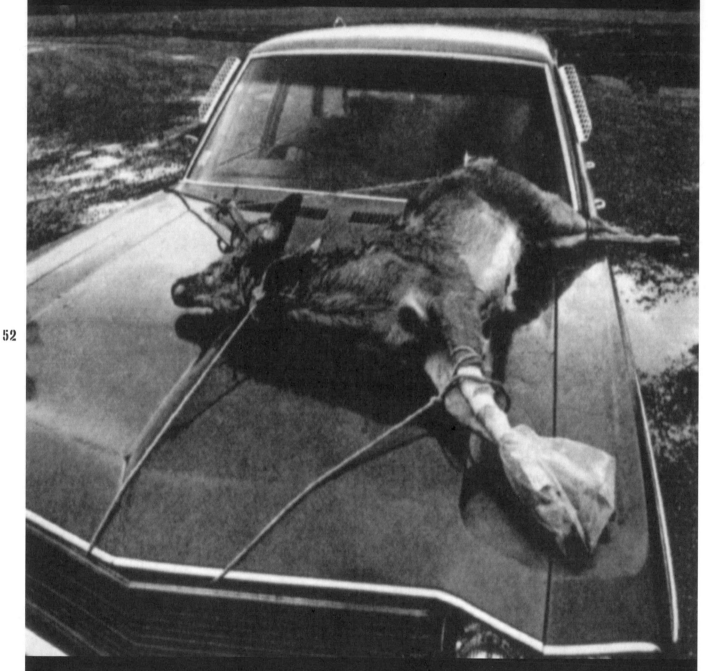

NO OPEN SEASON VOTES

52

REFUSE TO BE A TROPHY

OCTOBER SURPRISE

REJECT THEIR VOTE

LIE LIKE

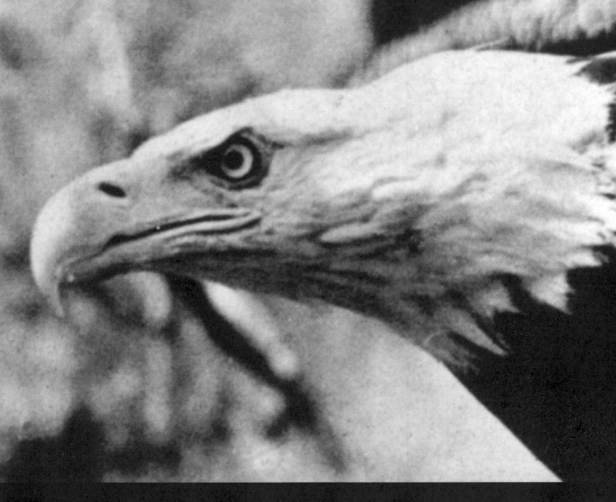

AN EAGLE

A CASUALTY OF GOP

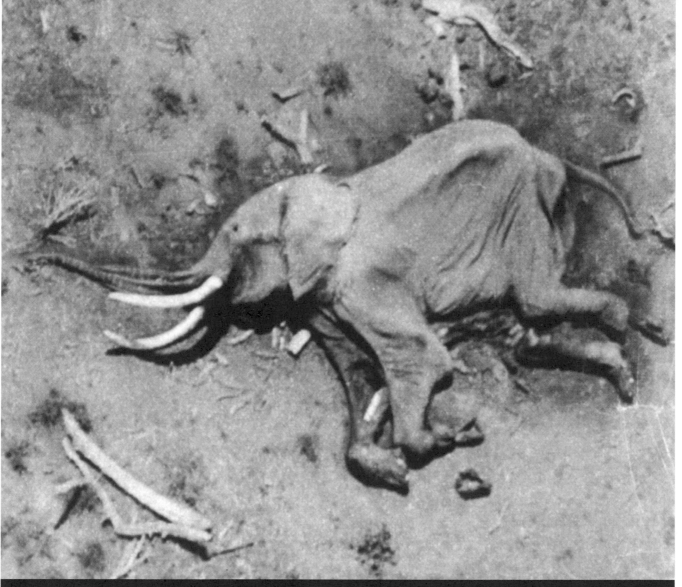

SPECIAL INTERESTS

SUPPORT THEIR RIGHT

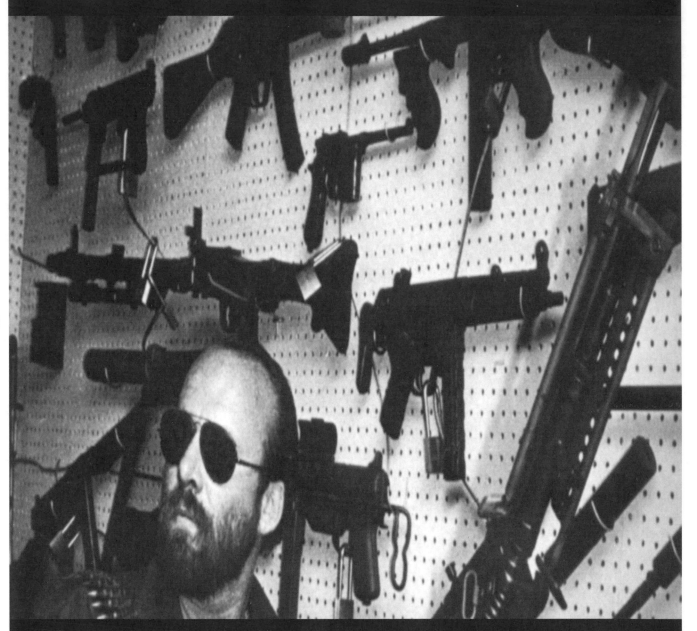

TO BEAR AN ARSENAL

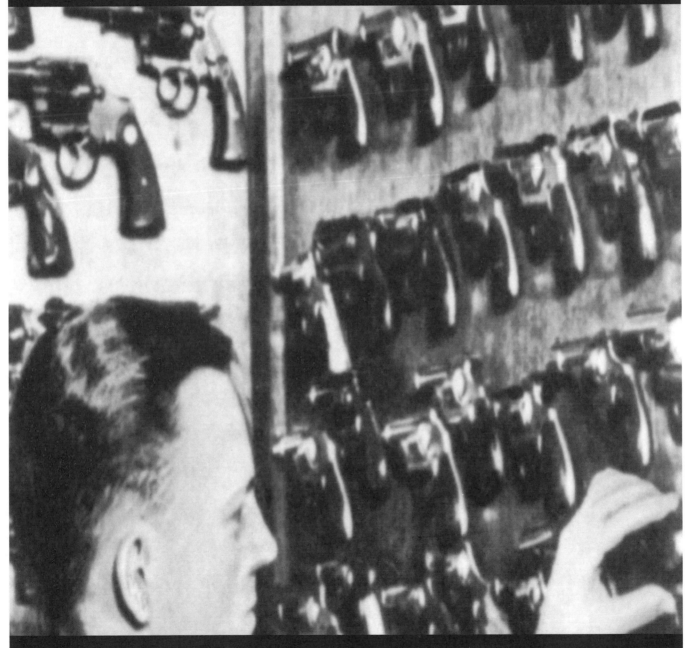

FREEDOM OF CHOICE

I CAN LIVE WITHOUT

SEPTEMBER COMMANDO

IF YOU LIKED SOMALIA

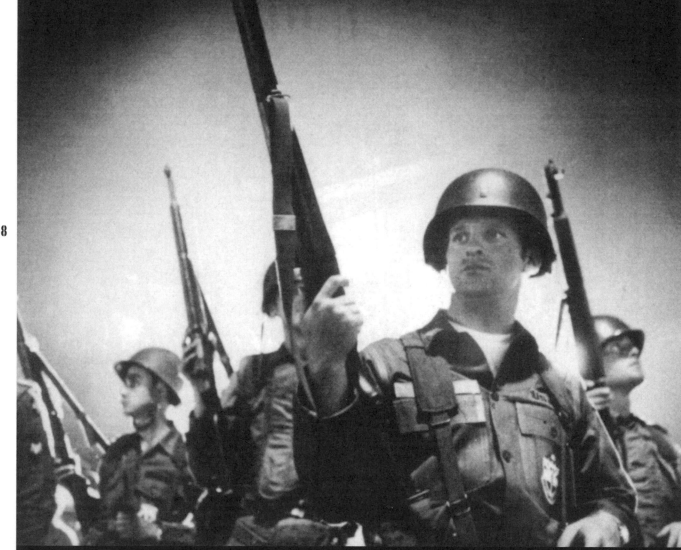

58

YOU'LL LOVE BOSNIA

IF YOU LIKED THE GULF

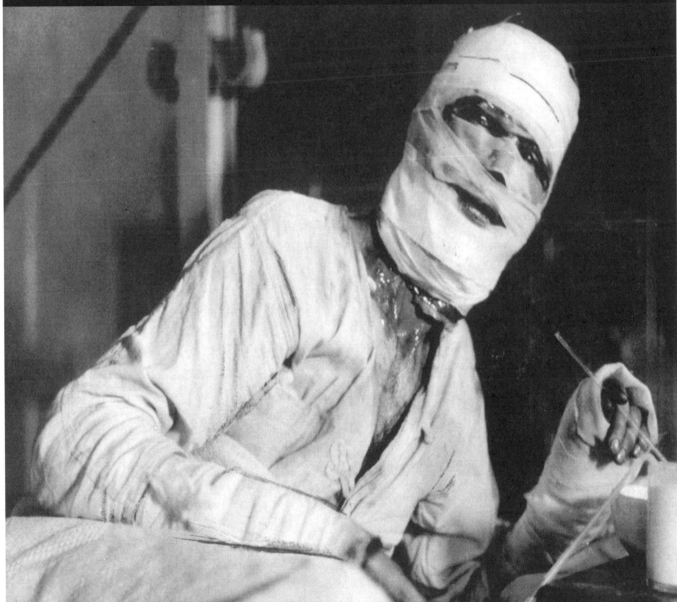

YOU'LL LOVE THE PEACE

SEPTEMBER COMMANDO

DEMOCRACY

RETURN TO
U.S. ARMY CENTRAL
IDENTIFICATION LAB.
FT. SHAFTER, HI

IN A GIFT BOX

MILITARY

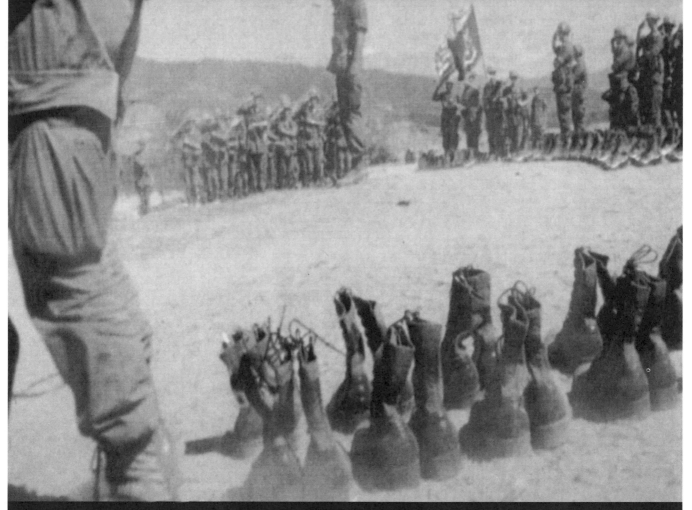

61

BOOT CAMP

PEACE HAS US

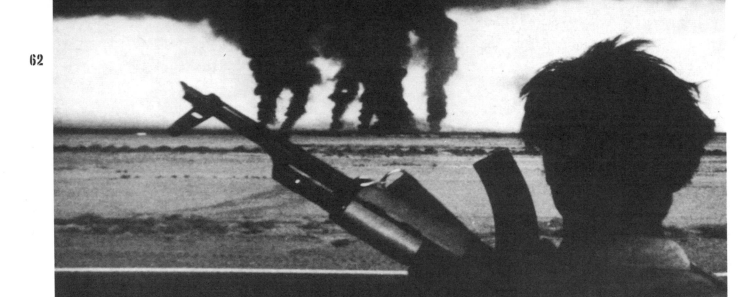

OVER A BARREL

SEPTEMBER COMMANDO

FRENCH STYLE PEACEKEEPING

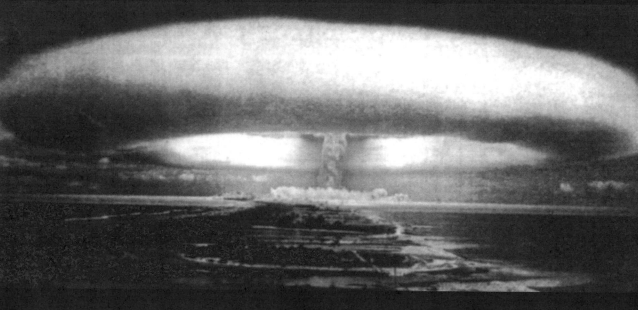

THANK YOU FOR THE MEMORIES

WHY CAN'T THE JAPANESE

ENOLA GAY

82

APOLOGIZE FOR 12/7/41?

NO SHIRT, NO SHOES

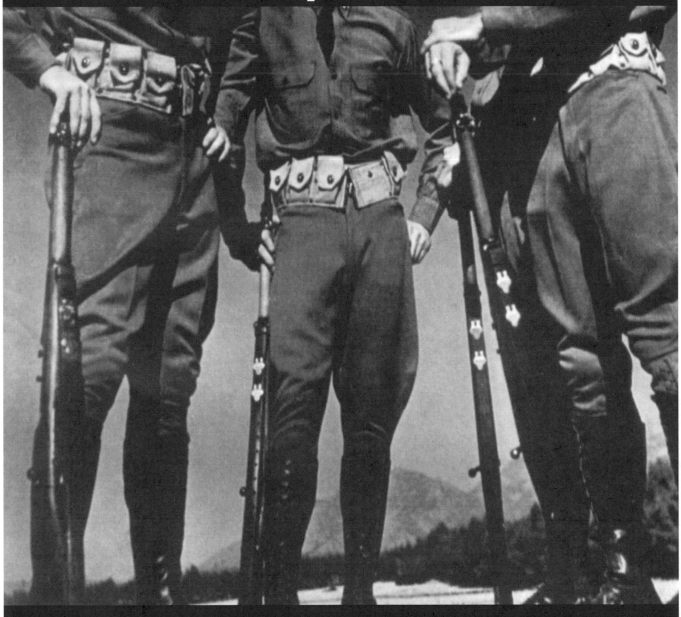

NO MILITARY SERVICE

BE ALL YOU CAN BE

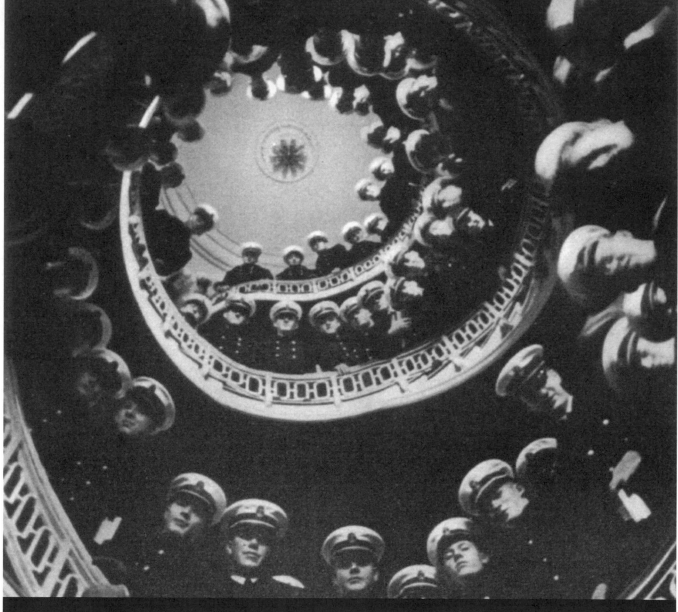

BE AN ARMY SEXIST

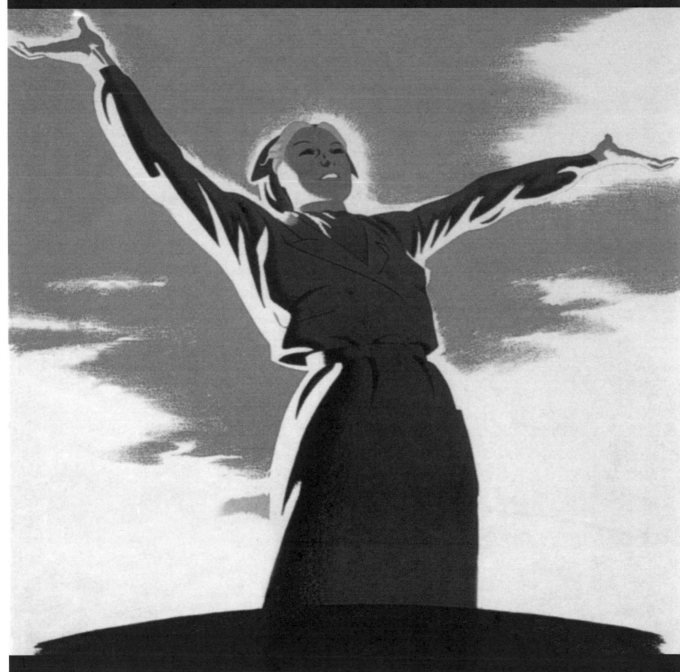

SEPTEMBER COMMANDO

PIN-UP YOUR HANG-UP

GIRL BEAUTIFUL

WE ARE NOT FOR SALE

THEY WILL RAIN

ON YOUR PARADE

WE PLACE (LIVE)STOCK

70

IN A MISS(ING) WORLD

WE WILL CONTROL

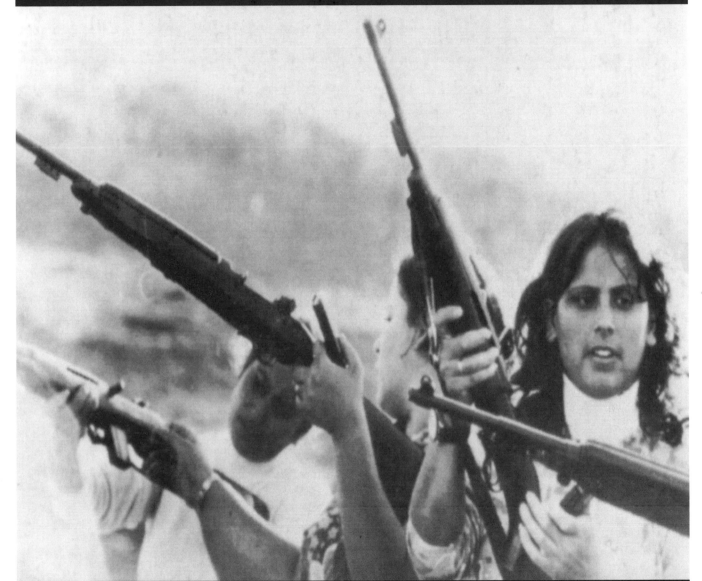

OUR OWN BODIES

SEPTEMBER COMMANDO

AMERICAN

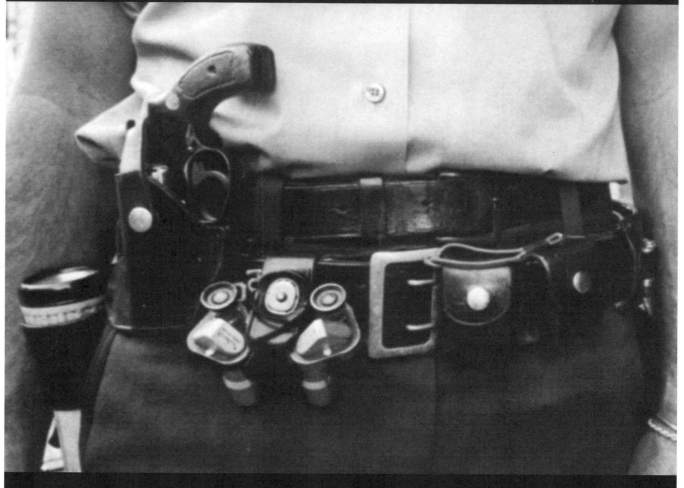

72

BIBLE BELT

WHO IS IN CONTROL

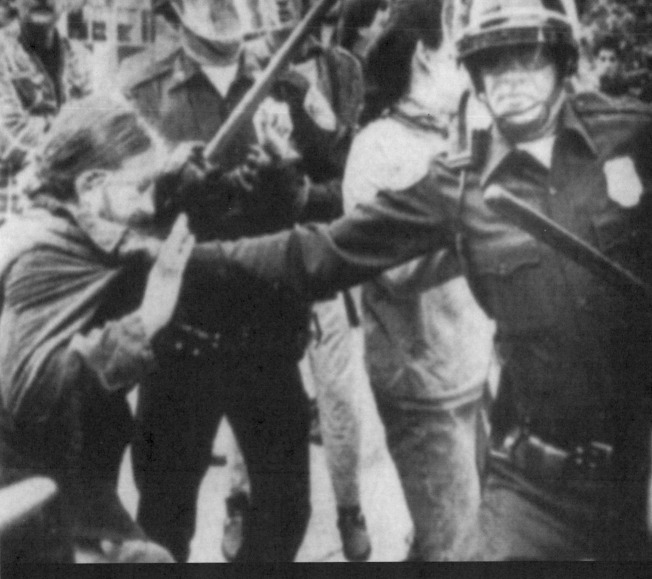

OF THOSE IN CONTROL

PUBLIC OPINION

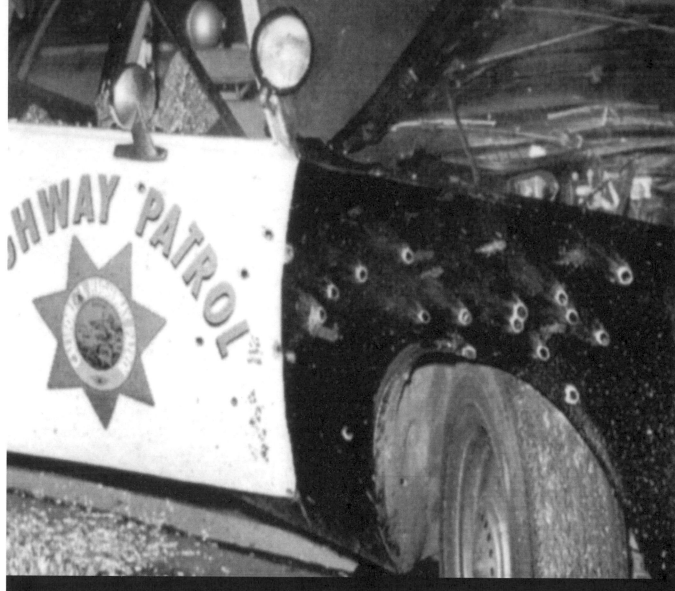

74

CLEARLY VOICED

START THE VIOLENCE

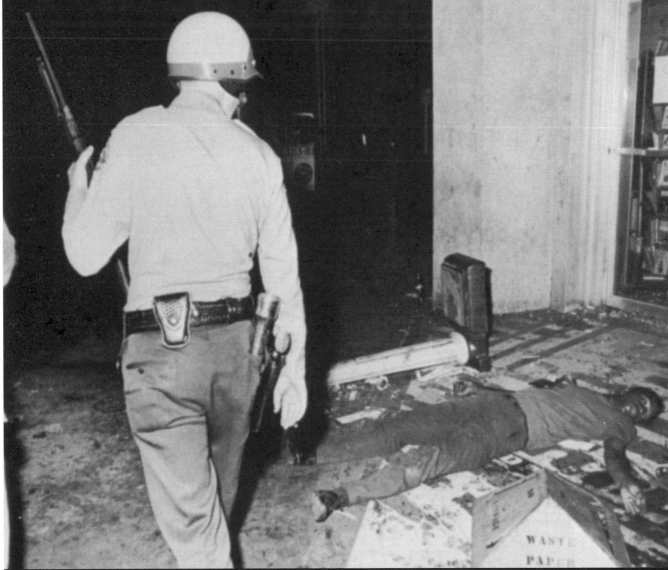

INCREASE THE POLICE

PROOF OF ALIEN

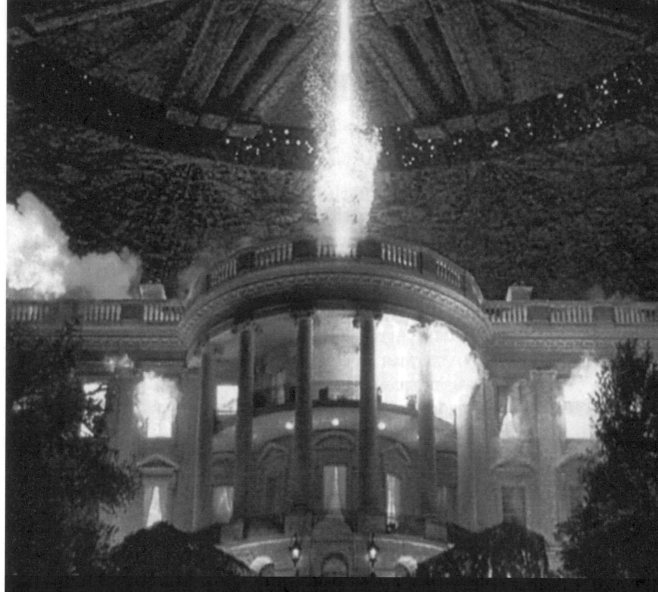

INTELLIGENCE

WE ALL AWAIT OUR

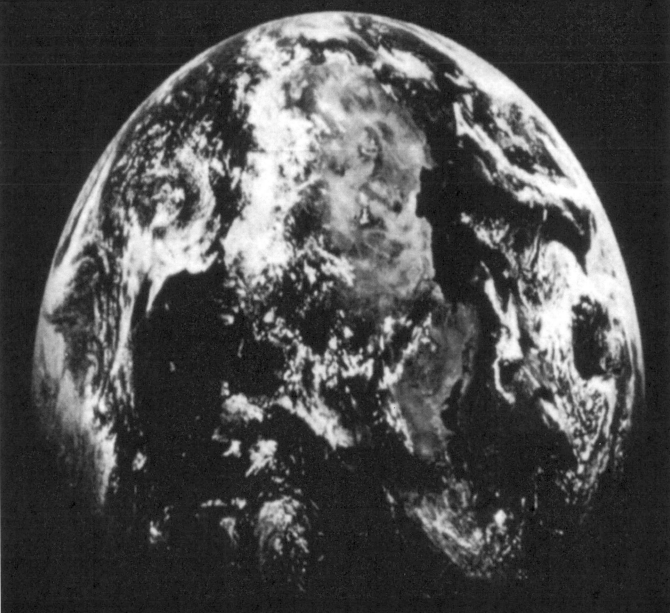

INDEPENDENCE DAY

SEPTEMBER COMMANDO

THE CHOICE OF A

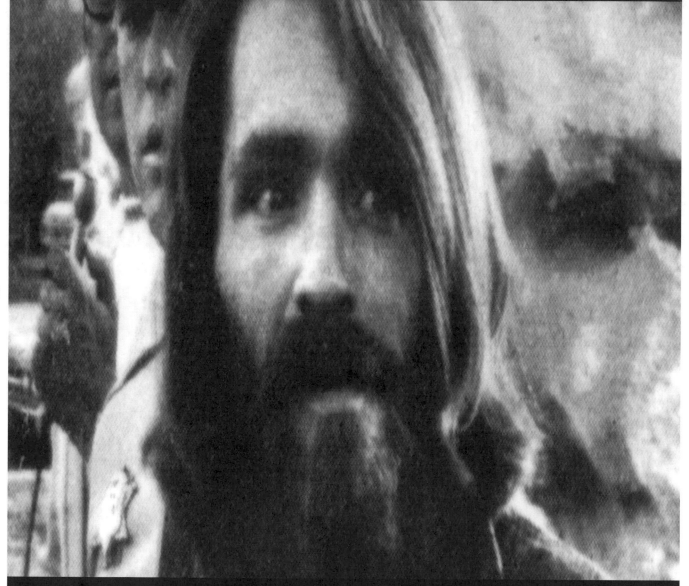

78

NUMB GENERATION

STAMP OUT APATHY

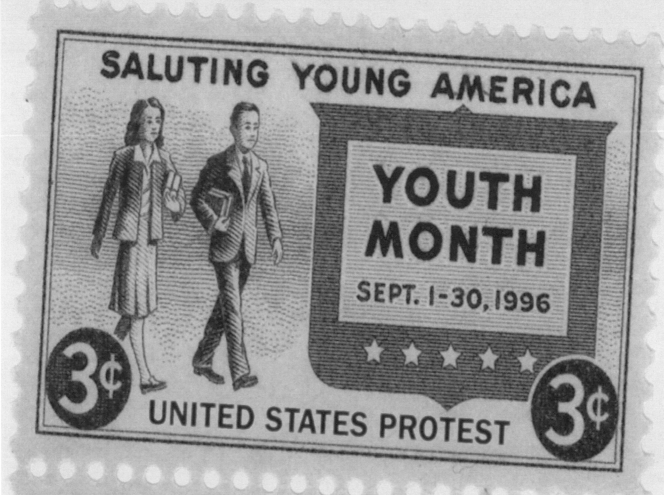

AGITATE THE STATE

PUNK ROCK VOLUME

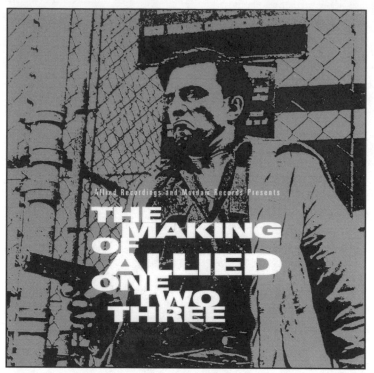

Left: Cover design for Allied's fiftieth release "The Making Of Allied One Two Three." This CD compilation featured nine of the labels' singles that were either not available on CD, or were not available at all anymore. The title, adapted from an excellent seventies crime flick "The Taking Of Pelham One Two Three," set the tone for the prevailing hoodlum movie theme. The first of my several homages to the world of cinematic design.

Below: Outer and inner tray card designs for the release. The theme was more about struggle than anything, symbolic reference to the labels' day-to-day existence.

Below left: CD folder design incorporating stills from classic film noir flicks. Vicarious cinematic living? Perhaps.

Bottom of page: CD folder reverse panels spread.

PLANET OF THE YATES

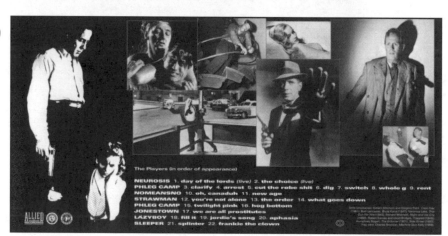

SEPTEMBER COMMANDO

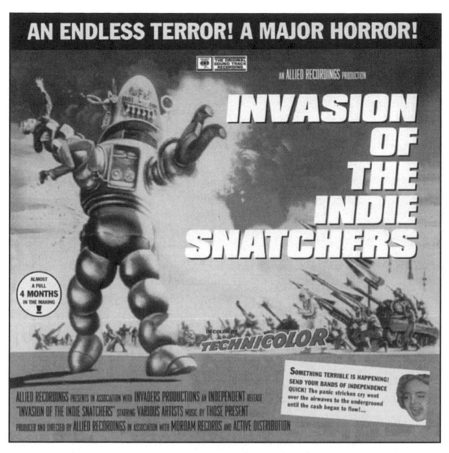

Above right: Cover design for the Allied CD compilation "Invasion Of The Indie Snatchers." A love of science fiction movies from the fifties and the visuals that accompanied them were the influence for the artwork. Something about the simplicity and naivety of the original designs seemed appropriate for the project; the pursuit of independence in the wake of a major label "sign 'em all, let the accountant sort 'em out" onslaught. A particular favorite, and the hours spent manipulating the originals in Photoshop paid off nicely.

Top of page and above: CD booklet back cover and outer tray card designs. A continuation of the idea of the major label as an invading alien presence, bent on the destruction of all. The image used for the tray card was from the movie "When World's Collide," very significant for the job at hand.

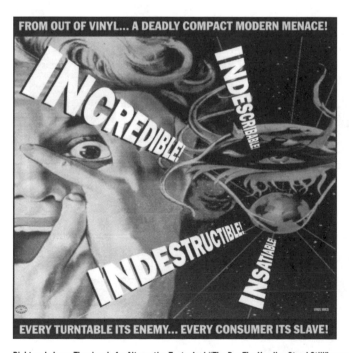

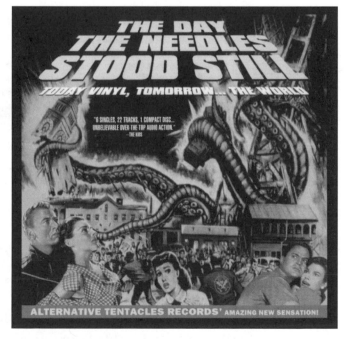

Right and above: The visuals for Alternative Tentacles' "The Day The Needles Stood Still" were a continuation of the ideas developed for "Invasion Of The Indie Snatchers" project. Elements borrowed from numerous fifties sci-fi flicks were combined to create these two homages to the B-movies that my brother and I loved so much as kids.

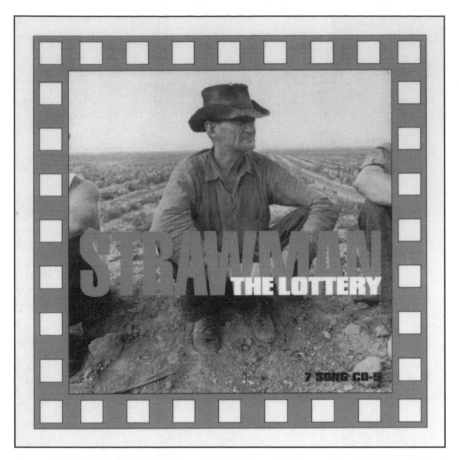

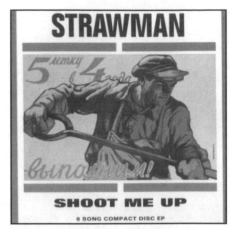

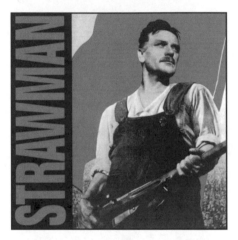

Above and at right: Working with STRAWMAN was always fun. Their working class anarcho-socialist posture lent itself beautifully to the Rodchenko-influenced red, black, and white designs that were the feature of their releases.

Below and at right: Cover and tray card designs for J CHURCH's "Analysis: Yes, Very Nice" on Allied, and (bottom right) cover design for their "Nostalgic For Nothing" singles compilation on Broken Rekids. All very simple: yes, very nice.

82

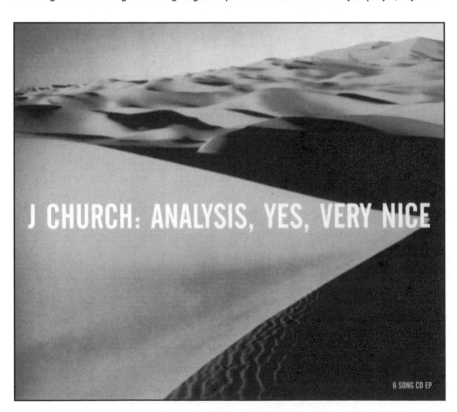

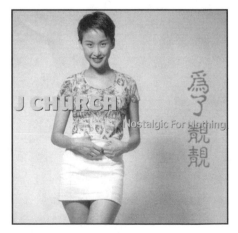

Right: Cover design to MARY ME's "Need Me Never." A hybrid of several elements, including an old firecracker package, an even older box of nails, and some science fiction image I lifted from a fifties adventure comic, this is one that I was particularly happy with. Looks a hell of a lot better in color though. But what can you do?

Below: Cover design to CARDS IN SPOKES' "Pool Party" single. The design featured four stills of Micky Dolenz I'd shot off the television screen from the movie "Head," and was based on artwork for the sixties Burt Lancaster movie, "The Swimmer." The water theme was appropriate and I like the finished job, although many reviews have assumed the faces belong to Bruce Lee. Those ignorant fools.

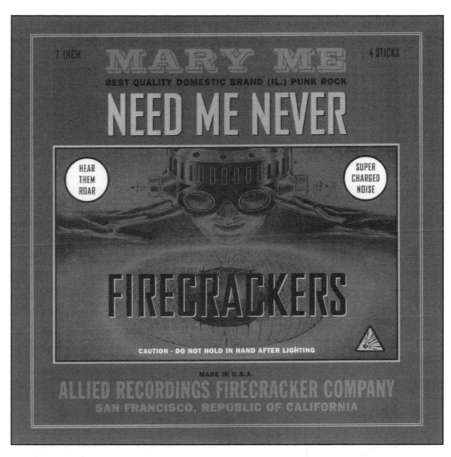

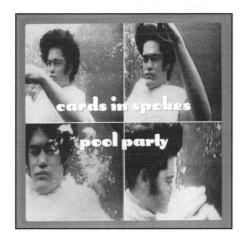

Right: Cover design to "Applied Science Versus The Arts," a Japanese released Allied label CD sampler on ZK Records. The cover artwork featured an illustration from one of Union Carbide's series of 'Big Hands of Industry' advertisements that ran throughout the fifties and sixties. They pushed the "benefits" of everything from uranium to radiation on the naive American dreamers of the time.

Above: The booklet back cover design was a mixture of various getaway vacation advertisements from forties era 'National Geographic' periodicals. The design styles from this period are wonderful and they never really seem to age, hence the rebirth in retro design that you see everywhere today. But hey, if it ain't broke, don't fix it.

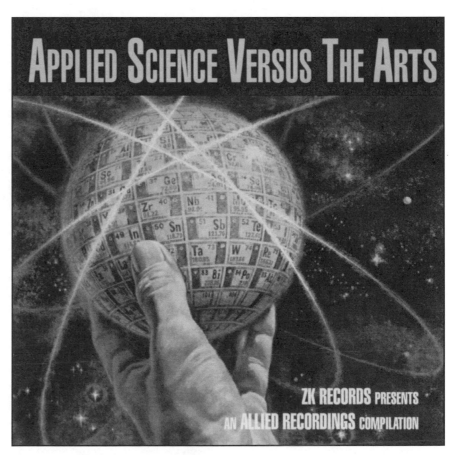

SEPTEMBER COMMANDO

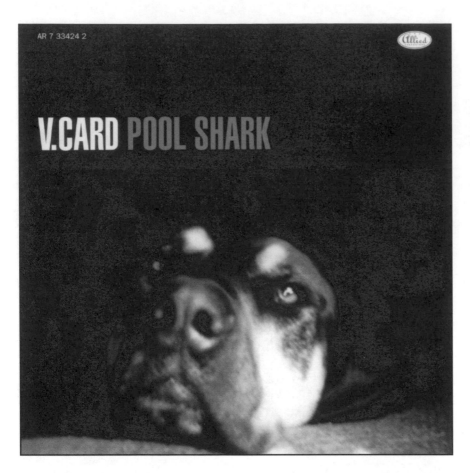

AR 7 33424 2

V.CARD POOL SHARK

Left: Cover design to V.CARD's "Pool Shark." Miles Davis' "Birth Of The Cool" was the obvious inspiration for this work. The records' title brought to mind smoke filled urban pool halls from the fifties and the jazzy era of the day.

Above: Tray card design to "Pool Shark." A snapshot the band had taken through their vans' windshield while on the road. Not the greatest photo in the world, but the colors were really cool. I was really happy with this project.

Bottom left: Cover design to V.CARD's "3 Piece Set." The diner theme was in reference to one of the songs featured, which dealt with waiting on tables in a restaurant on a daily basis. Given the theme, the Denny's sign parody (bottom right) was a given. And the archive drive-in image (below) used for the tray card design was an excuse to utilize yet another classic Americana image, and tie the whole package together.

84

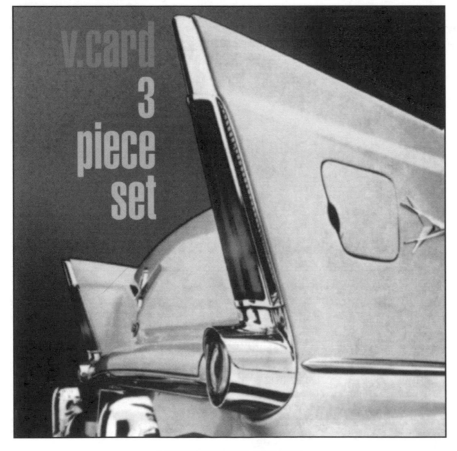

v.card 3 piece set

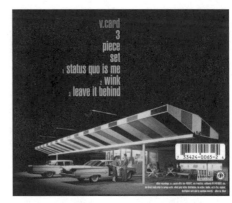

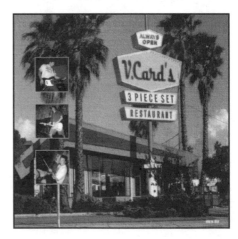

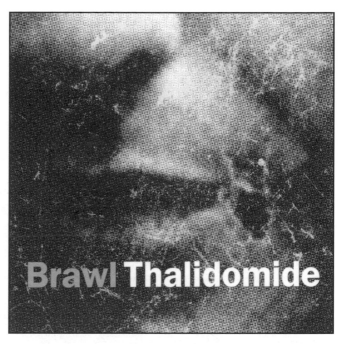

Above: Cover and booklet back cover designs to BRAWL's "Thalidomide" release. The general theme of the songs seemed to express a sense of isolation and alienation, hence the artworks' sombre mood. The cover and tray card (not pictured) photographs were liberally sampled from the brilliant photography of Richard Misrach. If you want beautiful photography with genuine social commentary then you need look no further than this guy.

Below right: CARDS IN SPOKES' "Stix, Nix, Hix, Pix" cover featured another slice of good old fashioned Americana, this time the drive-in movie. Hailing from England, I have never been fortunate enough to experience this phenomenon —unless they were showing "The Poseidon Adventure" continuously, England's weather would have put a considerable dampner on things— but have always held a fascination with it. So, when the band and I were struggling for ideas less than a week before artwork was due at the printers, they found some industry drive-in magazines from the seventies in the basement of an abandoned movie house. Technical manuals and publications can be endless sources of wonderful imagery. What to one person is a job or hobby becomes anothers' tools for creativity.

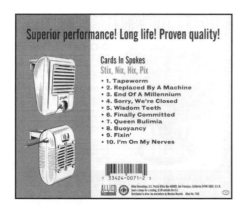

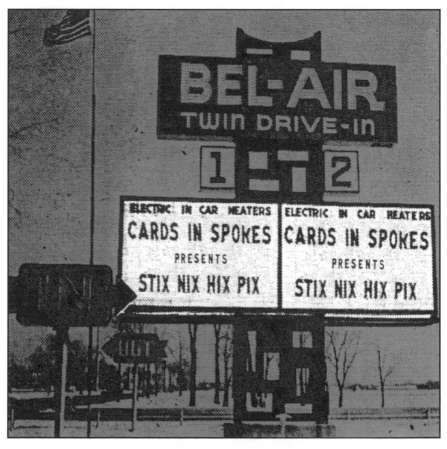

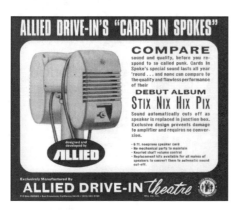

Above: Inside tray card design simply adapted an old RCA drive-in speaker ad from one of the journals.

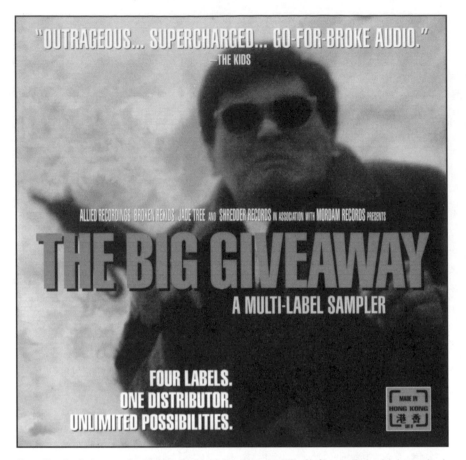

"OUTRAGEOUS... SUPERCHARGED... GO-FOR-BROKE AUDIO."
—THE KIDS

ALLIED RECORDINGS, BROKEN REKIDS, JADE TREE AND SHREDDER RECORDS IN ASSOCIATION WITH MORDAM RECORDS PRESENTS

THE BIG GIVEAWAY
A MULTI-LABEL SAMPLER

FOUR LABELS.
ONE DISTRIBUTOR.
UNLIMITED POSSIBILITIES.

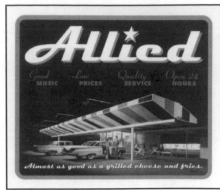

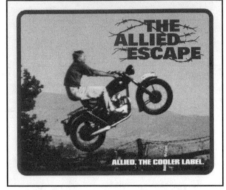

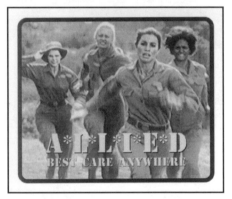

Above: Chow Yun Fat in a scene from 'A Better Tomorrow' made the cover of "The Big Giveaway," a four label promotional-only CD sampler that involved Allied, Broken Rekids, Jade Tree, and Shredder. Yet another example of the ever-popular theatrical poster style I was obsessing with, and continue to do so. Given the choice I'd drop this music scene design work in a second for a chance to work in the film industry. So for now, bands and labels alike must endure my surrogate career.

Below: Postcard design for Allied. Tongue-in-cheek visuals tie seat of creation to San Francisco. In my own little mind, sometimes that ain't too far from the truth. Hey, if you can't believe in yourself, who can?

Right column: Individual Allied sticker designs. The obsession with cinematic imagery reached new heights with homages to McQueen in 'The Great Escape,' TV's greatest sitcom 'MASH,' and Peckinpah's classic 'The Wild Bunch.'

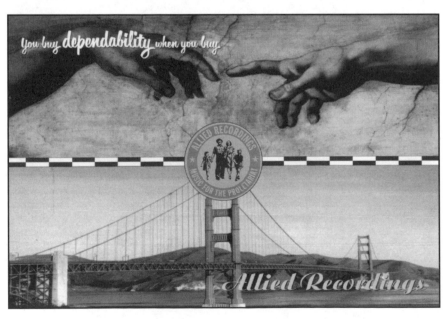

SEPTEMBER COMMANDO

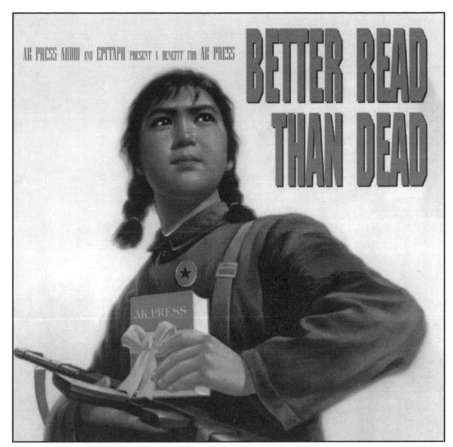

Above: Cover design for "Better Read Than Dead," a benefit compilation for the AK Press publishing wing from AK Press Audio and Epitaph Records. Inspired by the title, the artwork was born to carry the unabashed imagery of the classic revolutionary spirit. Some Photoshop manipulation here and there and we had the pin-up girl for the AK Press revolution. Whatever you think of China's human rights record, their propaganda material makes for great record covers.

Top left: Outer tray card design featuring triumphant peasants with AK Press banner fronting the parade.

Above left: Inner tray card design featuring a version of the "Make Every Hour Cocktail Hour!" piece.

Below: CD folder spread with glorious testament to the women of the revolution.

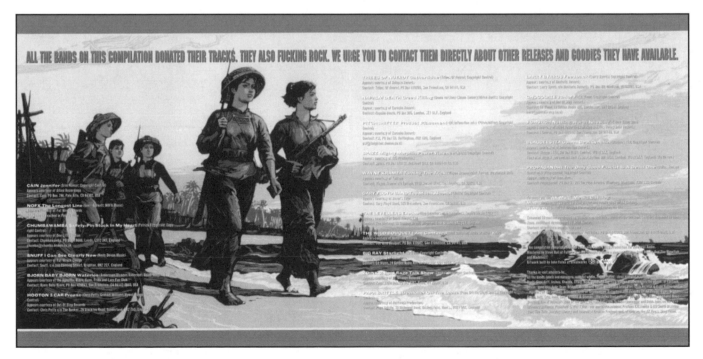

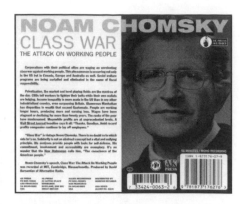

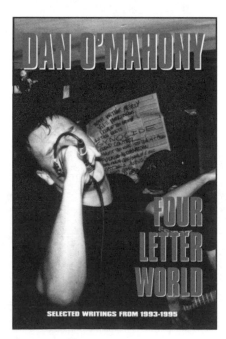

CLASS WAR
THE ATTACK ON WORKING PEOPLE

NOAM CHOMSKY

Left: Cover design to NOAM CHOMSKY's "Class War: The Attack On Working People." AK Press, geniuses that they are, have released three of Chomsky's lectures to-date on CD, helping to make the true Voice of America more readily available to the ignorant masses. The artwork was inspired by the beautiful work of Blue Note designer Reid Miles. If ever a label owed its' identity to a single visual artist, this would be the one.

Above: Tray card design to "Class War" sports a fine photograph of the dapper Chomsky; anarchist, MIT professor of linguistics, and Nobel prize winner. It was an honor to work for an individual that I hold in great regard, as should we all.

Below: The Stealworks logo (cheap version).

88 Below left: Cover design to DAN O'MAHONY's "Three Legged Race" book jacket. I haven't done but three designs for book jackets —besides my own— and this was my first. Bold and direct, like the writer's style, it's an effectively simple yet strong design.

Below center: Cover design to O'MAHONY's "Four Letter World" book jacket. Part of an ongoing series that will retain a uniform design structure, this is book two in the further adventures of "Book 'em, Dan O."

Below right: Cover design for fellow AK Press author G.A. MATIASZ' "End Time" book jacket. Created with some extensive work in Photoshop, it was just like the old school cut and paste approach, only with an electronic scalpel. Final image consists of elements from four individual sources.

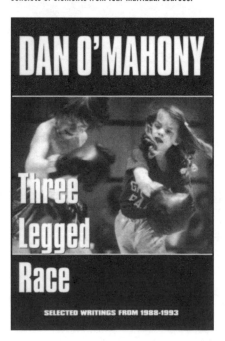

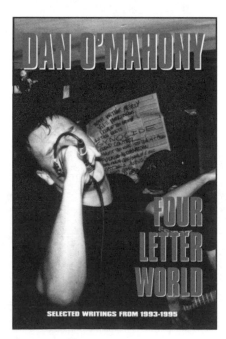

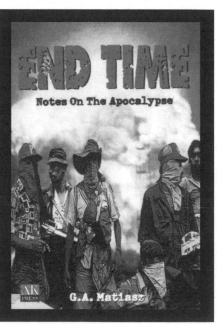

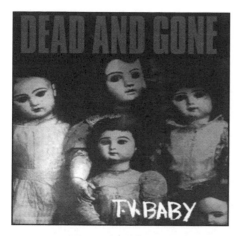

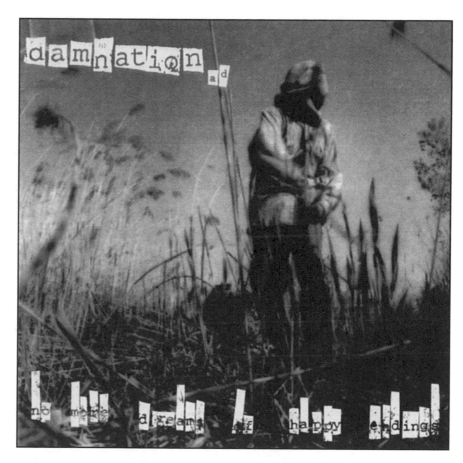

Above: Cover design to DEAD AND GONE's "T.V. Baby." This Prank Records project was another job where the band already had a basic idea in mind and had me enlisted to put the thing together. Usually I prefer to work without any restraints, but then I have to accept the fact that I am not in the band and defer to their opinions. At least sometimes.

Right: Cover design to DAMNATION a.d.'s "No More Dreams Of Happy Endings." The band supplied me with a series of almost surreal, dream-like photographs for me to work with throughout this job. All the images were turned into duotones in Photoshop to give them a more ethereal quality. Again, this was more of a layout and construction job than other work I've done.

Right: Cover design to a TEXAS IS THE REASON/THE PROMISE RING split single sleeve for the Jade Tree label. Although this job only took a couple hours to assemble, it turned out to be one of the projects I was happiest with, and was also very popular with those involved in the project. I think the paper stock used in the printing was a big plus, lending it the impression of an old school recording.

Below: The opposite side to the split single sleeve. In retrospect, I think I prefered the TEXAS IS THE REASON side on a visual level.

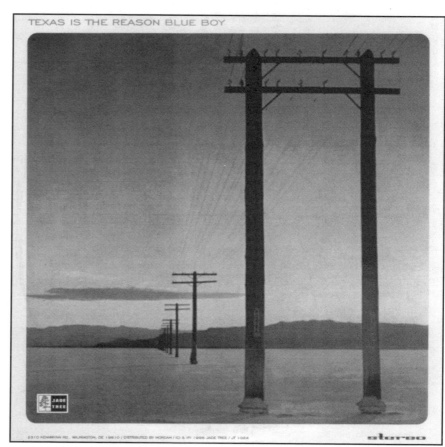

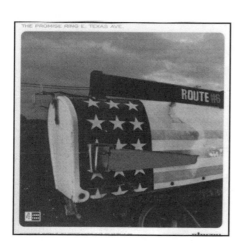

SEPTEMBER COMMANDO

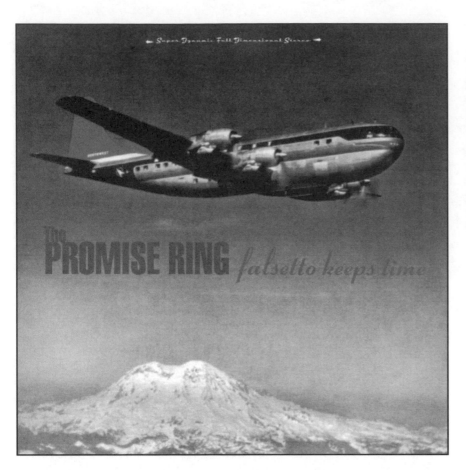

Left: Another of the recent Jade Tree single sleeves I've been responsible for, this one for THE PROMISE RING's "Falsetto Keeps Time." The archival images used and, again, the paper stock they were printed on, helped achieve the appearance of an older style release. The free reign given to me with the Jade Tree singles is another plus, leaving all avenues open to possibility.

Above: Back cover to the same single. Very vague, used more for the atmosphere involved with the colors than anything.

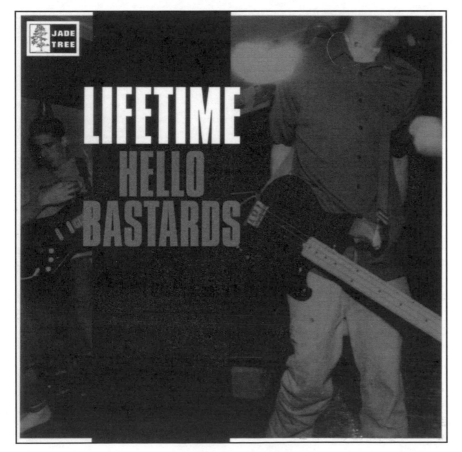

SEPTEMBER COMMANDO

Left: Front cover to LIFETIME's "Hello Bastards" album was a case of a band coming to me with a rough idea of what they wanted, in this case it was a play on an old Housemartins' cover that they were interested in. The inside of the CD booklet was a full color 12-page layout, something I'd never had an opportunity to work with before. I think it turned out to be a very solid, attractive design.

Below: Tray card design to the "Hello Bastards" release. Like the other photographs and old postcards utilized inside the booklet, the tray photo was an old snapshot found in a thrift store. Thrift stores make for some excellent sources of interesting imagery.

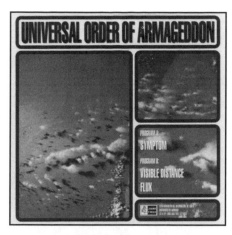

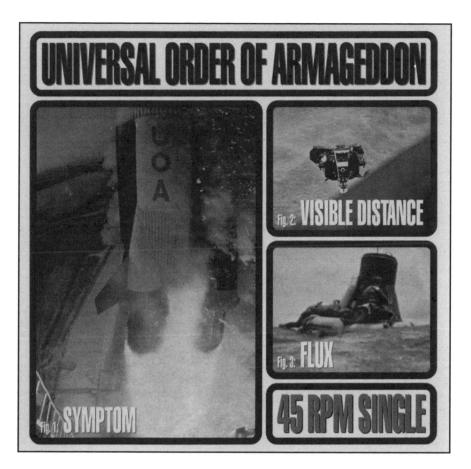

Right and above: NASA provided the visual influence for this sleeve for UNIVERSAL ORDER of ARMAGEDDON's "Symptom" single. The space program is both a fascinating technical achievement and an horrendous waste of taxpayer's money, but it does provide for some stunning imagery. I think my favorite piece about this design is the subtle manipulation of the 'USA' on the Saturn rockets' hull. Like with most things in life, it's the little things that count the most.

Right: Design for WALLEYE's "Familiar, Forgotten" consisted of a series of old photographs supplied by the band, some from family members, others from thrift stores. Very straight-forward design, simply creating sepia tone versions of the snapshots gave the layout a family photo album feel. The Jade Tree label has been a consistant source of interesting and creative projects, and is perhaps my favorite label to work for.

Below: Tray card design for "Familiar, Forgotten."

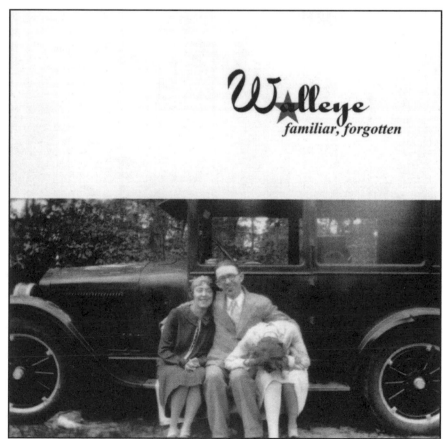

BUZZKILL

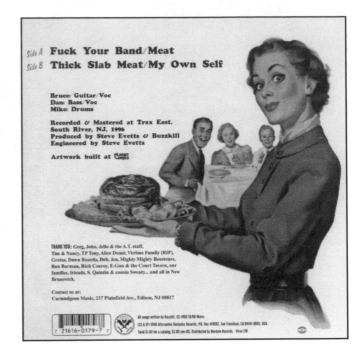

MEAT IS DINNER

Side A **Fuck Your Band/Meat**
Side B **Thick Slab Meat/My Own Self**

Bruce: Guitar/Voc
Dan: Bass/Voc
Mike: Drums

Recorded & Mastered at Trax East,
South River, NJ, 1996
Produced by Steve Evetts & Buzzkill
Engineered by Steve Evetts

Artwork built at PLANET YATES

THANK YOU: Greg, John, Jello & the A.T. staff,
Tim & Nancy, TP Tony, Alice Donut, Victims Family (RIP),
Grotus, Dawn Roorda, Deb, Jen, Mighty Mighty Bosstones,
Ron Burman, Rich Conroy, E-Gua & the Court Taverns, our
families, friends, S. Quintin & cousin Sweaty... and all in New
Brunswick.

Contact us at:
Curmudgeon Music, 237 Plainfield Ave., Edison, NJ 08817

All songs written by Buzzkill. (C) 1996 10/66 Music
(C) & (P) 1996 Alternative Tentacles Records, P.O. Box 419092, San Francisco, CA 94141-9092, USA.
Send $1.00 for a catalog, $2.00 non-US. Distributed by Mordam Records. Virus 179

7 21616-0179-7

PLANET OF THE YATES

Above: Front and back cover designs to BUZZKILL's "Meat Is Dinner" single on Alternative Tentacles. Pretty simple design work with a little nostalgic trip down memory lane style-wise. Concept was developed from some forties era meat marketing board advertisements found in various period magazines. Reminds me of when I was first starting out, influenced by, among others, Winston Smith.

Top right: Logo I developed specifically for work created at Alternative Tentacles.

92

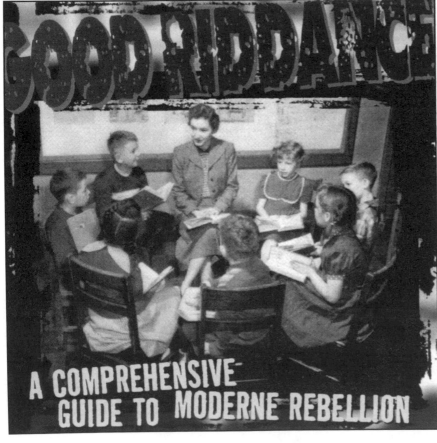

Left: Cover design for GOOD RIDDANCE' "A Comprehensive Guide To Moderne Rebellion" on Fat Wreck Chords. This was a fun one to be involved in and the band were easy to work with, which is always a plus. Design-wise it was somewhat of a departure in style, and it looks a lot better in full color, but overall I liked the results.

Below: Cover design for the McRACKINS' "Short And Sweet." Not my usual style and I was debating including this example, but I actually like it in a weird kind of way. The song title just screamed for a little homage to Oliver Stone's "Natural Born Killers." Sure, it's silly. But hell, the band's stage costumes are a couple eggs and a dog...

Right: PROPAGANDHI's "Less Talk, More Rock." Most of this was basic construction work. They had an idea in mind at the offset and the cover image, taken from an old rodeo poster, was already supplied. Still, it was a nice experiment in cramming vast tracts of text into a small format. Should have been titled "Less Art, More Words." The nicest people to work with though. Because they were in Canada.

Below: Tray card design to "Less Talk, More Rock."

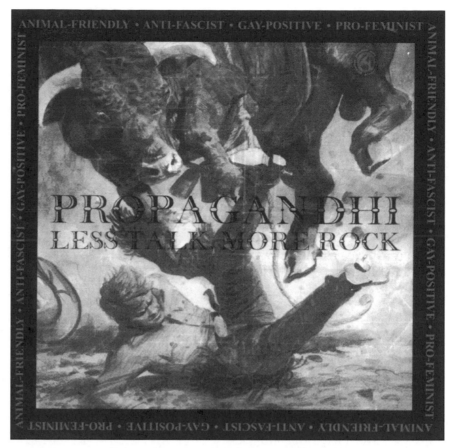

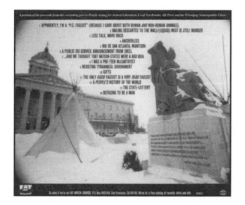

Right: Cover design for NAILBOMB's "Proud To Commit Commercial Suicide" full length. Nailbomb was a side project of Fudge Tunnel's Alex Newport and Sepultura's Max Cavallera. This was a live album they recorded in Europe at their first, and last, show. They asked me to do it because they liked my work. I liked theirs, so it worked out fine.

Below: JAWBREAKER's "Dear You" was my first experience with the world of major labels. Let's just say they make it a hell of a lot more complicated than it needs to be. Didn't design the cover, Adam's usually the band's idea man. I got to do the construction on it though, and it's always been fun to help these guys out. Too bad the majors destroyed 'em.

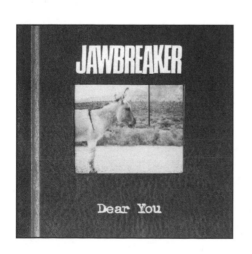

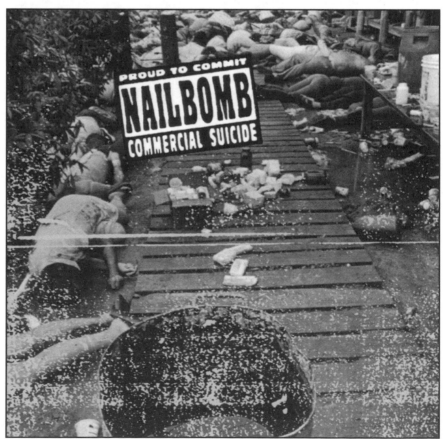

SEPTEMBER COMMANDO

PLATES (PAGES 12-79)

UNTITLED (THEY PERPETUATE OUR INSECURITIES). 1996.
UNTITLED (WE MUST NOT VALIDATE THEIR ASSUMPTIONS). 1996.
UNTITLED (CAN YOU STAND UP TO THEIR SCRUTINY). 1995.
UNTITLED (PROXIMITY DOES NOT GUARANTEE INTIMACY). 1996.
UNTITLED (THE LIBERATION IS IN OUR HANDS). 1996.
UNTITLED (YOUR ATMOSPHERE IS CHOKING US TO DEATH). 1996.
UNTITLED (TOKEN GESTURES DO NOT MOVE US). 1996.
UNTITLED (WE CANNOT NAVIGATE WITHOUT DESTINATION). 1995.
UNTITLED (CAN THEY SECURE YOUR ATTENTION). 1995.
UNTITLED (OUR OBSERVATION IS OUR SAFETY NET). 1996.
UNTITLED (WE MUST ASCEND THEIR STONEWALL). 1996.
UNTITLED (THERE IS NO COMFORT IN YOUR ALIENATION). 1996.
UNTITLED (THE ISSUE OF TRUST). 1995.
UNTITLED (THE NEIGHBORHOOD WATCHED). 1995.
UNTITLED (THERE IS LITTLE ROOM FOR MISCONCEPTION). 1995.
UNTITLED (THE GAMES BEGIN). 1996.
UNTITLED (THE HANDS CUFFED). 1995.
UNTITLED (THE GAMBLE). 1995.
UNTITLED (GOLDEN ARCH VILLAIN). 1996.
UNTITLED (ALL ARE WELCOME WITH EXCEPTIONS). 1995.
UNTITLED (THE DISENFRANCHISED PATRIOT). 1995.
UNTITLED (ALL WRAPPED UP IN OURSELVES). 1995.
UNTITLED (THE PLEDGE). 1996.
UNTITLED (TOLERANCE IS CHILDS' PLAY). 1994.
UNTITLED (FREEDOM OF SPEECH AND JUST TAXATION). 1994.
UNTITLED (IGNORANT PEOPLE SHOULDN'T BREED). 1996.
UNTITLED (THE QUESTION OF LIFE). 1996.
UNTITLED (HUNGRY FOR AWARENESS). 1995.
UNTITLED (AN EYE FOR AN EYE). 1995.
UNTITLED (MUST WE ALL STARVE FOR YOUR ATTENTION). 1995.
UNTITLED (ONE SMALL STEP FOR A MAN). 1996.
UNTITLED (LIFE, LIBERTY, AND THE PURSUIT OF TRIVIA). 1995.
UNTITLED (A SPANNER IN THE WORKS). 1995.
UNTITLED (MAKE EVERY HOUR A COCKTAIL HOUR!). 1996.
UNTITLED (WOULD YOU RAPE YOUR MOTHER?). 1995.
UNTITLED (DIG MY TRASH). 1996.
UNTITLED (THE HIGH COST OF THE CARE FREE). 1996.
UNTITLED (A BAD TASTE IN THE MOUTH). 1996.
UNTITLED (SHOOT ME UP). 1996.
UNTITLED (TAKE A DEEP BREATH). 1996.
UNTITLED (THE HUNT). 1995.
UNTITLED (OCTOBER SURPRISE). 1996.

UNTITLED (LIE LIKE AN EAGLE). 1995.
UNTITLED (ENDANGERED SPECIES ACT). 1995.
UNTITLED (THE RIGHT TO BEAR GRUDGES). 1995.
UNTITLED (FREEDOM OF CHOICE I CAN LIVE WITHOUT). 1995.
UNTITLED (IF YOU LIKED SOMALIA...). 1995.
UNTITLED (IF YOU LIKED THE GULF...). 1996.
UNTITLED (DEMOCRACY IN A GIFT BOX). 1996.
UNTITLED (MILITARY BOOT CAMP). 1996.
UNTITLED (PEACE HAS US OVER A BARREL). 1996.
UNTITLED (THE MEMORY LINGERS). 1995.
UNTITLED (THE RHETORICAL QUESTION). 1995.
UNTITLED (NO SHIRT, NO SHOES, NO MILTARY SERVICE). 1996.
UNTITLED (THE ANNAPOLIS 500). 1996.
UNTITLED (DON'T LET THEM BABY YOU). 1995.
UNTITLED (WE ARE NOT FOR SALE). 1996.
UNTITLED (THEY WILL RAIN ON YOUR PARADE). 1996.
UNTITLED (MISS WORLD). 1995.
UNTITLED (SELF-DETERMINATION). 1996.
UNTITLED (AMERICAN BIBLE BELT). 1995.
UNTITLED (WHO IS IN CONTROL OF THOSE IN CONTROL). 1995.
UNTITLED (PUBLIC OPINION CLEARLY VOICED). 1996.
UNTITLED (ASS BACKWARDS). 1996.
UNTITLED (PROOF OF ALIEN INTELLIGENCE). 1996.
UNTITLED (WE ALL AWAIT OUR INDEPENDENCE DAY). 1996.
UNTITLED (THE CHOICE OF A NUMB GENERATION). 1995.
UNTITLED (SALUTING YOUNG AMERICA). 1996.

All originals are 7" x 9.5" photographic prints.

ACKNOWLEDGEMENTS

Jennifer Fisher, for support, friendship, being there, and bearing with me and my work load. Thanks. My mom, Audrey, for creating this creator. My brother, Paul, and his family; I miss you, kiddo. My grandparents, Jack and Nora Yates. Ramsey Kanaan, for his continued friendship, fellow Hong Kong violence appreciation, and encouragement in creating this book. Dan O'Mahony, the only guy I know to actually hurl himself off the wagon and survive. Allison and Susan Tenzer for helping make a tough situation easier. Kath and David Wakeling. Bill and the other good-for-nothing anarchists at AK Press US/UK. Jon "kinda sometimes Active" Elliott, for sharing the blame once again. Walter Glaser and the late great Sean Kelly, current and former roommates you'd be hard-pressed to beat; and Em for filling in the gap. Mark Ryan, for his Oscar-contention performance in '(My Dad's Name Is) Missing (From The Movie).' Greg Werckman, friend and sell-out; and Candice. Eric Rose, friend and cop-out. Biafra; especially for being about the only individual from an old school hardcore band to not even consider embarking upon a reunion tour. Sean and Kristin, new kids on the A.T. block. Gary Davi, the Mac mack and technical wiz. Smelly, king of the late (but great looking) t-shirts. Ken, Tim, Mike and the other 'Union Yes' folks at H&H Platemakers. Karin Gembus. Winni Wintermeyer/3AM, one who truly understands that it's all for those damn meddling kids. V.Card, particularly Tim Schmoyer, for not showing up at my house and for endless (literally) telephone shenanigans. Peaceful Meadows; magnets for washed-up session musicians everywhere. Cards In Spokes; crazy enough to make an 8,000 mile road trip in order for me to see 'em play live. Var Thelin/No Idea Fanzines & Records. Jon "Fresh" Resh. Nick Faigin. Stéphane Trouplain, for long distance friendship and the show at Les Silos in France; and the nutty French government for paying for it. Joachim Hiller/Ox Fanzine. The kids at Punks With Presses for prices you can afford; but fold those damn posters, would ya? John Pinson, CPA to the stars, and folks like myself. Dr. Scott Dye, for reconstructing my right knee ligaments and meniscus; the physical therapy department at Davies Medical Center for their continuing efforts to bring said knee back to soccer playing status. The team mates I had to abandon when I blew out my knee; should never have joined that over-30 league. Tim, Darren, and the bands at Jade Tree, for provding me with an outlet for some of my best work. Mel Cheplowitz/Shredder Records, mostly for the entertaining arguments about the use of day-glo colors in design work; they don't belong! Chris, Brian and the other folks at Fat Wreck Chords. Gary Held and crew at the Revolver USA empire. Mordam Records; those fine folks who lounge around all day and trade in Allied releases en masse at local retail stores. Daniel Toledo, the boy from Brazil; one day I will get down there and then you'll be sorry you ever kept inviting me. All the bands I've had the pleasure of taking for millions... I mean working with, through Allied. Anyone who bought or even looked at a copy of 'Stealworks,' despite the fact it looked like crap. I can't believe you reprinted that, Ramsey. And of course, to the Dogger; long may he grant me the priviledge of answering his every whim.

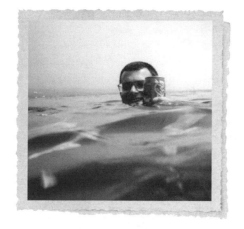

Ramsey Kanaan: anarchist, multi-media kingpin, champion of lost causes, and sometime porn star; pictured here savoring the soda that would ultimately lead to his undoing. Kickbacks and secret sponsorships such as this became all too common, eventually leading to his overthrow and a life of self-imposed exile in the occupied West Bank.

"Someday a real rain'll come and wash all this scum off the streets."
—ROBERT DeNIRO, Travis Bickle, "Taxi Driver"

SOME RECENT TITLES FROM AK PRESS

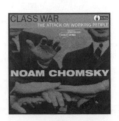

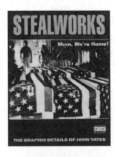
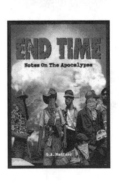